Sir Roland Penrose
was born in 1900 and educated in Reading
and at Cambridge University. From 1922 until 1936 he lived
in France, painting and becoming the friend of surrealist
painters and poets. After returning to London, he organized
the International Surrealist Exhibition in 1936, and until 1939
painted and exhibited in London and Paris with the Surrealist
Group. After the Second World War (during which he
served as a War Office Lecturer) he became one of the
founders of the Institute of Contemporary Arts, of which for
many years he was President. He also served on the British
Council and the Arts Council, and as a Trustee of the Tate
Gallery. He died in 1984, a few weeks after his friend Joan
Miró. Roland Penrose's publications include *Picasso: His
Life and Work*, *Man Ray* and *Scrapbook 1900–1981*.

D0953963

WORLD OF ART

This famous series
provides the widest available
range of illustrated books on art in all its aspects.
If you would like to receive a complete list
of titles in print please write to:
THAMES AND HUDSON
30 Bloomsbury Street, London WC1B 3QP
In the United States please write to:
THAMES AND HUDSON INC.
500 Fifth Avenue, New York, New York 10110

MIRÓ

ROLAND PENROSE

141 illustrations, 54 in colour

THAMES AND HUDSON

Printed and bound in Spain by Artes Graficas Toledo S.A.
D.L TO-837-1985

Contents

A period of growth

In an attempt to sum up the conflict which can take place in a poet or an artist between inspiration and reason, Guillaume Apollinaire described two different kinds of artist: those who accept without challenge the dictates of their muse, 'who are like a prolongation of nature and whose works in no way pass through the intelligence', and those others who 'must draw everything out of themselves and not at all from their daemonic urge, no muse inspires them. They live in solitude, and nothing is expressed except what they themselves utter in agitation.'[1]

It would be impossible to assign Joan Miró to either of these categories because he belongs essentially to both. To say that he is a 'prolongation of nature', guided subconsciously by his daemon, is a means of describing the highly personal qualities in his work which have held him close to the marvels of nature all his life. At the same time he is by no means only an innocent poetic voice; there is in Miró a highly trained contemplative counterpart to unselfconscious spontaneity. He is also one of those artists whose expression comes, in Apollinaire's words, from 'effort upon effort, attempt after attempt, to formulate that which they desire to formulate'.[2]

It is probably necessary that all artists destined to achieve great eloquence should combine the mystery of inspiration with an intellect capable of probing not only the world around them but also the validity of their own work. This intellectual curiosity is necessary both for the extension and perfection of their own talent and for the mastery of techniques which can enlarge and enrich their means of expression. Miró is an artist who has never lost his burning desire to experiment, and to probe deeper into the nature of reality, but intellect has never been allowed to stifle imagination.

7

No artist has deeper roots in his homeland, and in the art of the past, than Miró. The artistic influences he has absorbed from his contemporaries are diverse and often mysterious, but his inherited qualities are much more easily traced. By birth and by ancestry he is a Catalan, a native of the province of Catalonia which covers much of north-eastern Spain and includes the Balearic Islands. Although he has travelled to many foreign countries, his native Catalonia has only one rival in his heart: France, where he has an active group of friends, and where the cultural atmosphere of Paris has attracted him for many years.

Joan Miró was born in Barcelona in 1893. He comes of a line of skilled craftsmen. His father was a prosperous goldsmith who kept a shop in the Pasaje del Crédito, one of the narrow passages that still exist among the tightly packed blocks of houses and crowded streets in the heart of the old city. Close by on one side are the elegant arcades of the Plaza Real, leading into the Ramblas with their ceaseless flow of life, and on the other stand the ancient Gothic palaces that surround the Cathedral. But although he grew up amid the hubbub and the smells of a busy Mediterranean port, brilliant in its colours and the variety of its trade, Joan soon discovered that he was really more at home in the great open spaces of the Catalan countryside.

Early in life he announced to his family that he wished to become a painter, but his father turned a deaf ear. In 1910, at the age of seventeen, the young man found himself dutifully accepting a job as a clerk in an office. This made him so unhappy that in the following year he became seriously ill, and his father sent him to recover at a newly acquired farm near the foot-hills overlooking the coastal plain, south of Tarragona. This farm was to be a place of great importance in Miró's life. It consisted of a solidly built farmhouse surrounded by several acres of olive trees and vines. Near by was a hill town, called Montroig (red mountain) because of a shaggy outcrop of red rock neatly crowned by the masonry of a small chapel (a romantic feature which was to make its appearance in Miró's

8

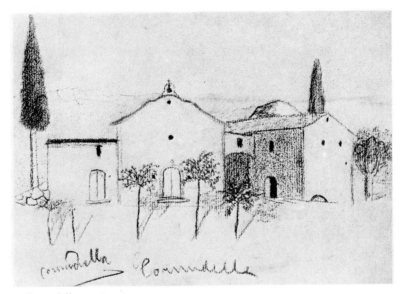

1 *Cornudella* 1906

early landscapes). It was in this part of Catalonia that Miró's family had its roots: his paternal grandfather, whose name was also Joan Miró, had been a blacksmith in the ancient village of Cornudella. As a child his grandson paid him frequent 1
visits, not only for the sake of his rather fragile health but also because of the enchantment he found in the wild, rugged mountains and the fascination of the creatures, plants and flowers which became known to him in every detail.

The family of Dolores Ferrá, Joan's mother, came from Majorca. Her father was a cabinet-maker, which meant that Joan inherited from both sides of the family the traditions of skill and style necessary for fine workmanship. It is, in consequence, understandable that an inborn love of nature and the arts should have led to a severe crisis due to a sense of frustration when his father insisted on a business career. Before his breakdown, Miró had occasionally managed to attend classes at the Escuela de Bellas Artes, 'La Llotja', the same official academy in Barcelona where, some twelve years before, Picasso had for a brief moment astonished his professors by his

prodigious talent. Miró had been recognized by his tutors, Modesto Urgell and José Pascó, as a promising pupil who could make pleasant drawings from nature during his excursions to the mountain villages; an early example of his inherited skill can be found in a jewellery design. But he tells us with characteristic candour that he gained there the reputation of being 'a phenomenon of clumsiness'.

On his return from Montroig, once more in good health, Joan was allowed to enter an art school in Barcelona which had as its head a painter of great intelligence, Francisc Galí. This school provided a very different atmosphere. Galí had devised ways of awakening in his pupils an acute sense of observation. He took them for excursions into the mountains, telling them to 'wear a crown of eyes round their heads';[3] he encouraged them to take an interest in chamber music and poetry. It was his teaching of drawing that impressed Miró most deeply. Placing an object in the hands of a blindfolded pupil, Galí told him to become so well acquainted with it by touch that he could afterwards draw what he had felt without seeing it. Under Galí's tuition Miró found that his perception of form and his ability to interpret it developed rapidly.

In 1915 he attended certain classes at the Sant Lluch circle, and met two other young artists, Joan Prats and Joseph Llorens

2 *Design for jewellery* 1908

3 *Wharves* 1915

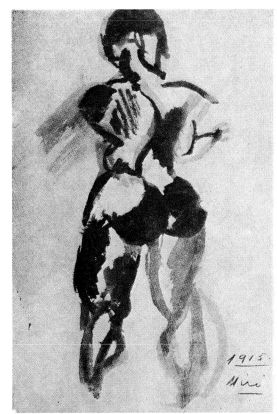

4 *Nude* 1915

Artigas, with whom he formed lifelong friendships. The circle owed its reputation to a former student, the Art Nouveau architect Antoni Gaudí. His extraordinary inventions in building, which include the gigantic steeples of the cathedral of La Sagrada Familia and the admirable decorations and terraces of the Parque Güell, had already stirred the enthusiasm of the younger generation in Barcelona. His use of flowing organic shapes, and his revolutionary techniques, have influenced Miró deeply throughout his life.

In 1910 the rebellion against his father's plans for his future had coincided with Miró's dissatisfaction with the traditional methods of teaching art at La Llotja. This was the first major crisis in a life which has since been punctuated with periodic upheavals, each bringing with it marked changes in Miró's work. Their frequency and violence is all the more remarkable because of his apparent calm and the gentleness of his nature. This inner fire was to break through again in 1919 when his discontent with the provincial atmosphere of Barcelona made him leave home to explore new horizons.

A consciousness of the great revolution that was taking place in the arts in Paris grew steadily in Miró. In 1916, an exhibition of French contemporary painting brought to Barcelona by the dealer Vollard had impressed him greatly, and when the Ballets Russes of Serge Diaghilev came in 1917–18 Miró eagerly watched the performances from the gallery. In 1917 he met the provocative and rebellious dadaist Francis Picabia, who between visits to New York exhibited some of his work in Barcelona and edited four numbers of his outrageous avant-garde magazine *391*, which contained his own drawings of machine-like constructions. Most of the text was written by him, but there were also contributions from Max Goth, Max Jacob and Georges Ribemont-Dessaignes, and a full-page *calligramme* by Apollinaire in which words and visual images were inextricably combined.

The infiltration of avant-garde ideas from Paris during the First World War gave Miró his first chance to appreciate the

importance of the contemporary French poets. He became convinced that poetry and painting were inseparable, and felt an immediate sympathy for the poets Pierre Reverdy and Maurice Raynal, who also visited Barcelona. The attraction of Paris was strong, but as long as the war lasted Miró could not go there. Meanwhile, his growing restlessness was temporarily overcome by his concentration on his work. He began to paint in the small upstairs room at his home in the Pasaje del Crédito, the same room about which he was able to say, more than twenty years later, that he still painted in the room where he was born.

It became increasingly obvious that one day Miró would make his way to Paris, but before he left Barcelona he was already able to establish a reputation within a small circle. His friends Prats, Artigas and E. C. Ricart shared his ambitions and encouraged him. In 1918 he held his first one-man exhibition at the Galerías Dalmau. The paintings he showed astonished all who saw them, not so much by the subject-matter as by the brilliance of the colour and the originality of the style, already apparent even though he was at this time strongly influenced by the Fauve painters. Four types of subject had occupied his attention: still-life, landscape, portraits and nudes. The themes in themselves are ordinary enough, but there is something surprisingly new and personal in every picture. In the still-life studies of the familiar bottles, bowls, apples and flowers, each object has been seen with a new vision and examined for its own essential qualities. Each bottle or jar has a character of its own, its surface enclosing an intangible inner space. The apples are round and solid, spread on cloths which can sometimes be reminiscent of Cézanne, although painted with a brilliance of colour which belongs more to the daring experiments of the Fauves. Angular lines that thrust into the picture from the foreground create a convincing sense of the third dimension without the use of the conventional rules of perspective. In the landscapes, too, perspective is also completely lacking, and yet the eye seems to penetrate far into the distance. *6, 7*

5

13

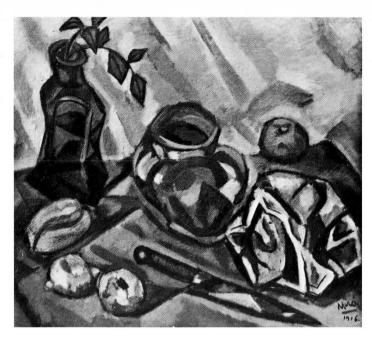

5 *Still-life with*
knife 1916

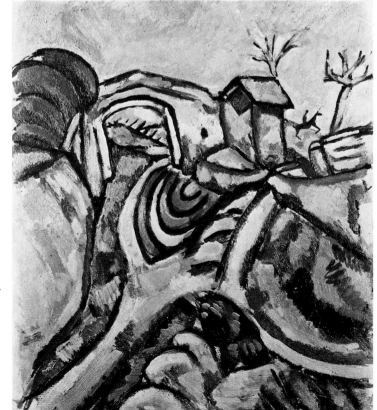

6 *The Road from*
En Güell 1917

The Museum of Modern Art,
New York

This may be caused by a path which leads in from a corner and twists into the picture with such vigour that it entices the eye deep into the landscape, where the spectator finds himself surrounded by trees and houses, with perhaps a church or a bridge, until he meets the sky, often filled with clouds shaped characteristically by the Mediterranean wind. Every detail has its rhythm, which is linked to the rhythms of the shapes around it, reminiscent of the arabesques and the bold calligraphy that we still find in Spanish peasant tradition, where every name painted on a cart has a compelling flourish so strong that the eye dances along with delight over each letter.

There is also a simplification of form that can be traced to cubist influences. Miró had seen the work of Picasso and Braque,

7 *The Path, Ciurana* 1917

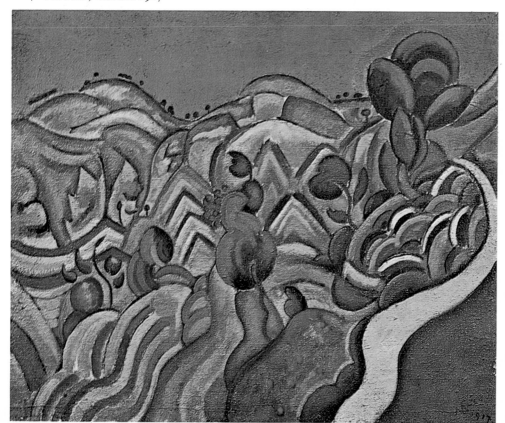

chiefly in reproduction. He was attracted by cubism as a style though he did not share the same purpose of dissecting and analysing each object. He used angular forms to create a movement that led the eye deep into the picture. When the subject was a hill town such as Montroig, Miró interpreted the rectangular pattern of the houses, stacked closely together with cubist rigour like a hard geological formation. He had already abandoned the intention we find in his early drawings of making a literal copy of the landscape and, with a clarity that stems from the brilliant light of Catalonia, he controlled the emotional appeal that his subject had made on him. In order to make every part of the painting reveal its own individual meaning, whether it were a tree, a ploughed field, a path, a mountain, a house or the clouds, he no longer hesitated to emphasize or deform its appearance according to his feelings.

Miró's treatment of reality came to a large degree from his instinctive feeling for the rhythms which underlie the traditional patterns of peasant art, and also from another equally strong native tradition which is to be found in Romanesque Catalan painting. Miró was thoroughly acquainted with the riches of the early medieval frescoes that abounded in the churches of Catalonia, each figure full of a characteristic life. Here, again, there is the simplification of form, the flow of curves, and the bold use of distortion to heighten the emotional effect, which are typical of all Catalan art.

These influences show themselves strongly in some portraits
8 Miró made of his friends in Barcelona. In the portrait of the painter Ricart (1917) he combines the influence of the Catalan primitives with something of the expressionism of Van Gogh. There is a freedom in his use of colour which is reminiscent of the Fauves, but the violent rhythms of form and colour, particularly in Ricart's striped jacket, are Miró's own interpretation of the various styles that have impressed him. The portrait departs from the usual tendency to fill the background with vigorous decorative elements which is to be found in almost all Miró's still-life paintings of this period. Here the

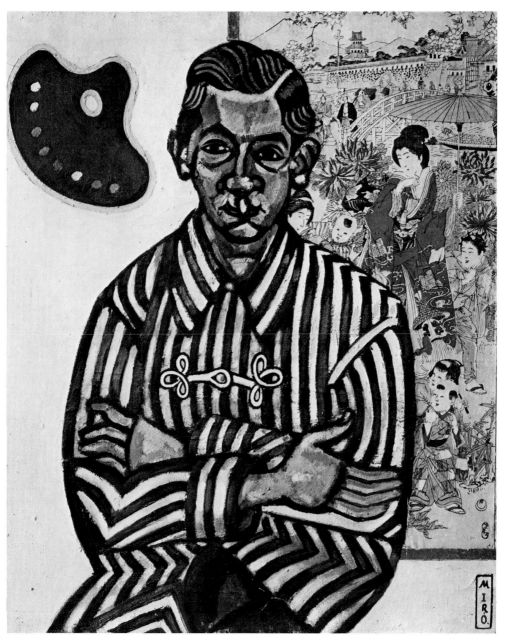

8 *Portrait of E. C. Ricart* 1917

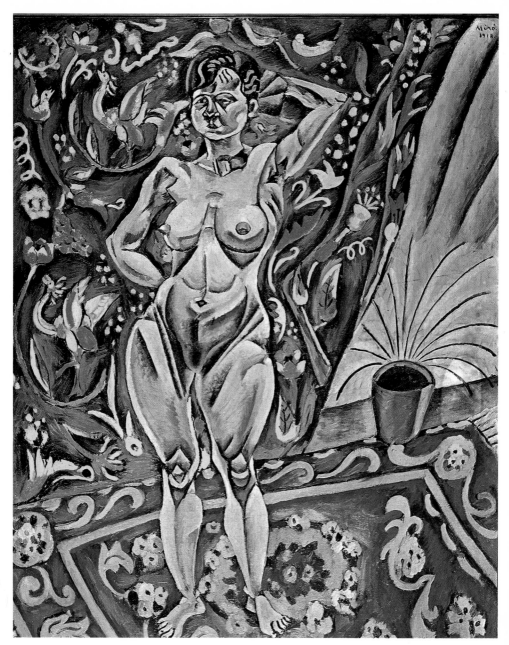

9 *Standing nude* 1918

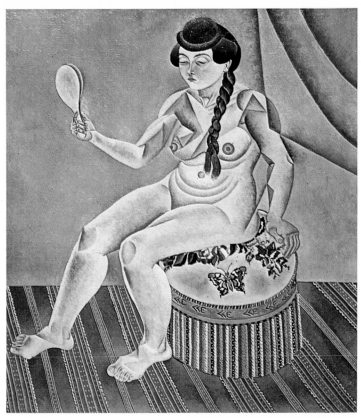

10 *Nude with a mirror* 1919

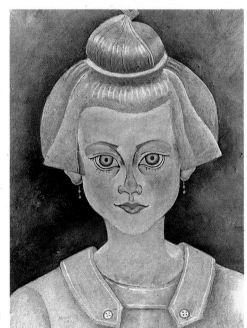

11 *Portrait of a little girl* 1918

figure is placed against a plain lemon-yellow wall on which hangs the diagrammatic shape of the painter's palette, but on the right the usual detail of patterned wallpaper or curtains is replaced by a Japanese print stuck to the canvas, a sign of Miró's continual search for new solutions.

Discussing the vigorous impact of this painting, Jacques Dupin remarks: 'In front of the human figure Miró seems to be seized by terror, overcome by giddiness to which he can only respond by a violent reaction involving his own being.'[4] The hieratic or even barbaric appearance of the figure, the strong contrasts in colour and the abrupt transition in the background, suggest a disquiet on the part of the artist which can only be overcome by a violence which borders on cruelty towards his model, and this is even more apparent in the fierce dissection he practises when he approaches the even more troubling presence of the female nude. In the large painting *Standing nude*, of 1918, in which the figure is placed in front of patterns of brilliantly coloured materials, Miró's deliberate analysis of the female form is neither flattering nor tender. The figure is built solidly, with the determination of an artist who will not allow one grain of sentimentality to weaken his work, who is so deeply moved by his subject that it is only by the clearest, most uncompromising statement that he is able to express his reaction.

The same objective candour appears again in the *Nude with a Mirror* of 1919, but here, as in the *Portrait of a little girl* of the previous year, Miró with admirably controlled precision allows a lyrical tenderness, such as is rare in his work, to illuminate the painting.

The realistic appeal of these early versions, when compared with the later evolution of Miró's image of woman, is of great interest. As Dupin suggests, there is usually a feeling of disquiet. This may be considered as a tribute to the mysterious problem of the representation of the human form, and in particular to the power of female magic. Miró's early purpose was a bold analysis of form, which later became an interpreta-

tion or a symbol of the meaning of the female presence as an integral part of the human condition. This could best be understood by paradox and by signs. It is the universal and magical influence of woman that has preoccupied him continuously, rather than the more obvious charms of the female form. We shall see later the violence and significance of his reactions to it.

12 *Garden with donkey* 1918

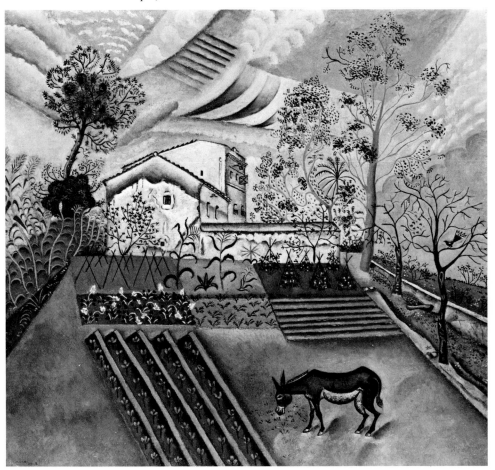

The originality and strength of Miró's work when it was shown at the Galerías Dalmau in 1918 was sufficient to convince his friends, and a small number of the more sensitive people who saw it, that a young painter of outstanding ability had appeared among them; but to the public in general his paintings were incomprehensible. This apathy convinced him that Barcelona was not the climate in which he could develop, and in 1919 he left at last for Paris.

This first contact with Paris was not wholly successful, although from then on he returned every winter. It was inevitable that those whose company he enjoyed should be as impoverished as himself; and, since the sale of his paintings was even more hazardous in a foreign city than at home, his only consolations for living on the verge of starvation were the museums and the excitement of contacts with friends who did understand and appreciate his work. Among them was Picasso, *13* who bought from the young Catalan a self-portrait, recently finished after long concentration on the precision and stylization of every detail. This painting, remarkable for the strength of its honest naïveté, was a development of an earlier, less successful, self-portrait showing Fauve influences. It is still one of Picasso's most treasured possessions.

THE SEDUCTION OF NATURE

As often happens when an artist is confronted with his work assembled in unfamiliar surroundings, dramatic changes came about in Miró's style after the 1918 Dalmau exhibition. Before that first visit to Paris in 1919, he had already become fascinated by well-defined detail, which could be situated in a painting so that it concentrated interest on certain areas and contributed to the rhythmic overall distribution of form. His former somewhat clumsy brushwork with its Fauve influences gave way *12* to clearly defined outline, and a new stylization of form showed more clearly than before the precise rhythmical influence of traditional Catalan art.

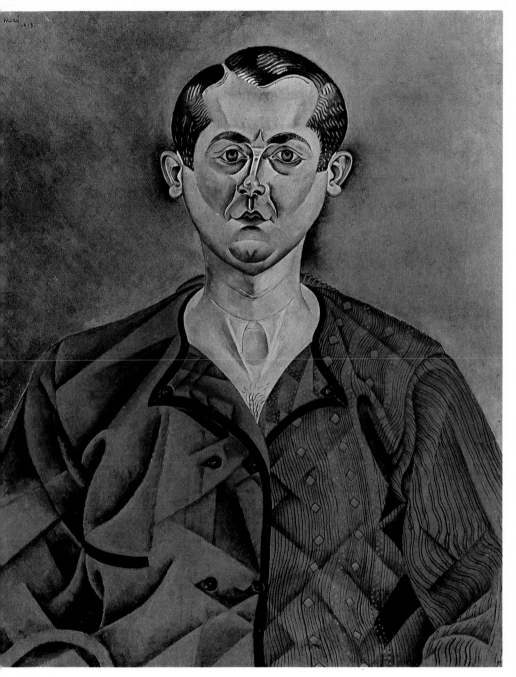

13 *Self-portrait* 1919

It was in 1919, during the long summer days back at Montroig, that Miró developed his new style. He was able there to contemplate in detail the rhythms of growth in plants or trees around him, and on a larger scale, the patterns of the cultivated fields and the outline of the distant mountains. Paintings such as *Vines and olive trees* and *Montroig, church and village*, both painted in 1919, have the quality of richly decorated embroidery, with the additional sense of deep recession into the distance, and a relation to reality which is in no way achieved by atmospheric effects or by the conventional rules of perspective.

There are still-life paintings belonging to this period, such as *Horse, pipe and red flower* (1920), which were painted among the objects and furniture of the farmhouse itself. We find in these that the florid exuberance of his earlier brushwork and colour has come under a strict control. The Fauve influence has given way to that of cubism, but without any slavish surrender on the artist's part. The disruption of form, and the severe, penetrating analysis, typical of early cubism, are absent. Each object is examined and treated individually in a representational style. Distortion is used only to strengthen the composition, which is held together in clearly defined geometric structure. Only the use of localized colour, and the deliberate lack of three-dimensional depth, relate these paintings to cubist techniques. To avoid a complete sensation of enclosure, however, Miró cleverly brings the distant landscape into the still-life as a reflection in the mirror.

We find the same approach in another still-life of 1920 known as *The Table*, in which he has greatly elaborated the presentation of familiar objects without imparing the homogeneity of his statement. The curves of the table legs lead vigorously upwards to a square top set with a rich feast for the eye; a rabbit and a cock give an undoubted impression of life, as do some vine leaves and vegetables. In contrast, there are a tattered dead fish and a heavy earthenware jar. All these are held in the grip of the bold angular patterns of the table-top and napkin, which recall the rugged peaks of the distant horizon.

16

15

14

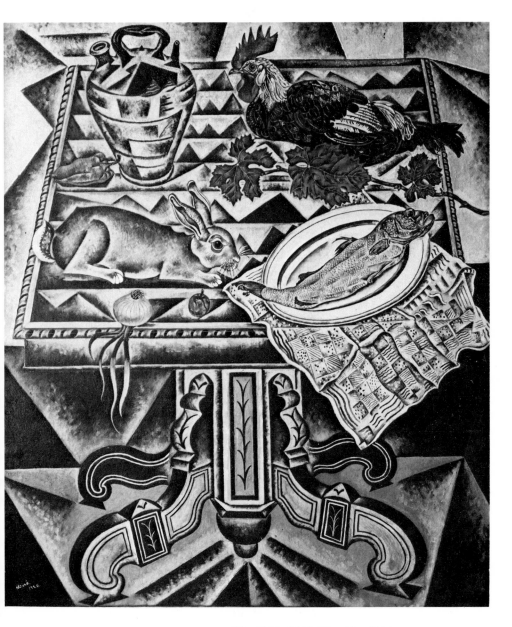

14 *The Table (Still-life with rabbit)* 1920

Miró has succeeded in capturing here an extension of realism that carries us beyond the exact representation of each object, and beyond the rigid stylization with which they are painted. The still-life breaks out into the life of the open air. The limited space, the furniture and the well-known farmhouse objects

15 *Horse, pipe and red flower* 1920

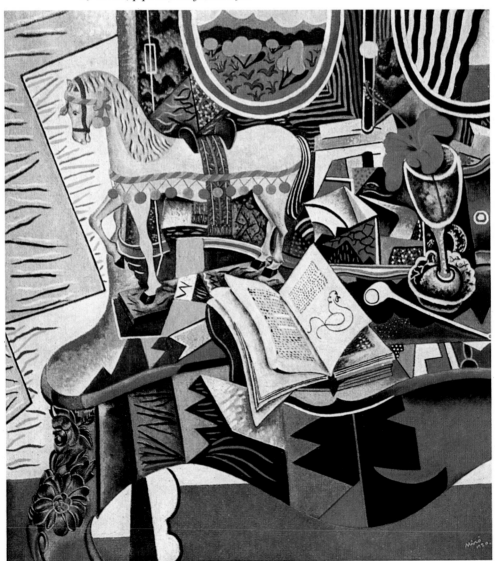

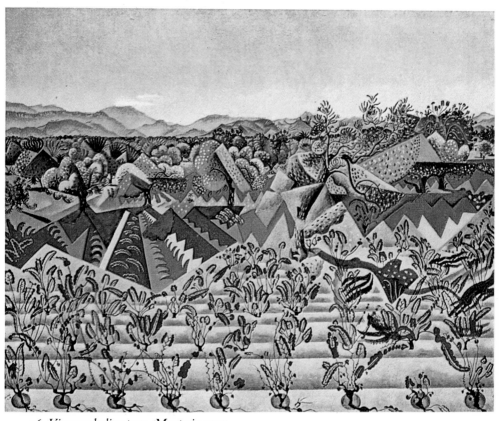

16 *Vines and olive trees, Montroig* 1919

become a window to a wide field of associations and distant visual echoes.

These paintings reveal a development towards the creation of a personal style in which Miró could follow his desire to extend his sense of reality and indulge his great ability to use precise and exquisite detail. They culminate in a large canvas, *The Farm* (1921–2). This early masterpiece is a truthful account of *17* the farmyard at Montroig, which he had known intimately for ten years. It is a sign of Miró's deep attachment to his early

surroundings that he still owns this property and returns there frequently to work. His familiarity with every detail and his love of the quiet rhythm of the life of this classical Mediterranean countryside made the task of painting this picture one of prolonged devotion. The canvas travelled with him when he left Montroig at the end of the summer of 1921; he continued it in Barcelona and completed it in his studio in Paris, where he had brought samples of grasses from Montroig.

The scene gives an accurate description of the many activities of a Catalan farmyard. It includes a woman washing clothes, a horse raising water from the well, a dog barking, birds, animals, insects, snails, lizards and even the cracks in the plastered walls. The character of every object, from building to stone and blades of grass, is captured with great care; each exists both independently and as an element essential to the whole composition. To convey so much information in one picture without confusion or overcrowding is in itself a triumph. It could only be achieved by a masterly restraint, a sense of design and an understanding of the way in which rhythms, harmonies and echoes can be made to work together to form a homogeneous composition. There is a ruthless elimination of irrelevant detail which makes it possible for Miró to establish poetic associations or 'rhymes' between unrelated objects, giving new significance to each. These links occur because of resemblances made easily recognizable by the clear definition of the shapes. For instance, the sun which shines in a clear blue sky is not required to cast shadows; instead it is linked to the earth in another way. The circle representing its presence is made to contrast with a round black hole in the earth from which grows the central feature of the picture, a giant eucalyptus tree. The circle again finds an echo in the round red and blue hole in the water trough on which a cock is standing. This is in turn balanced on the left of the picture by the red wheel of the cart. These deliberate repetitions or reversals of form or colour joined by intermediary rhythmic patterns create by cross-reference a visual and conceptual unity within the composition. They

provoke unlimited speculation on the endless play there can be between contrast and similarity, between negative and positive.

Since the painting is to some extent an inventory of those things and creatures that had interested Miró most deeply for many different reasons, it is not surprising that they should become the prototypes of symbols that recur throughout his later work. For instance, the ladder with a bird perching on it later develops into one of his obsessive signs, the ladder of escape, which provides a means of communication between the tangible and the intangible. Here it rises from the solid earth to become a perch where birds can find safety or fly away. The ladder is also related by its shape to a stool near the centre of the picture which stands out clearly like a large capital A, reminding us of the frequent and significant use that Miró makes of letters and numbers throughout his work.

Another painting of major importance, *The Farmer's Wife* 18 (1922–3), was begun in Montroig and finished in Paris. While still closely linked in sentiment with *The Farm*, it introduces some startling new developments. There is stringent simplification of form and deliberate distortion. The extraordinary disproportion between the woman's feet and the other parts of her anatomy is new and prophetic. There is also a surprising contrast between the style of the amiable but monstrous cat, which, like the rabbit and the woman, is candidly representational, and the schematic drawing of the charcoal fire and the chimney behind it. The hearth is indicated by a pale circle in the foreground above which a line mounts like a step with sharp angular bends towards the profile of a large black cowl, its chimney. There is a new freedom, a fantasy, and a disregard for homogeneity of both style and scale, which herald further revolutions in Miró's work but which do not destroy the overall harmony of the composition.

The gigantic feet of the farmer's wife, however, have a more personal significance. To quote Jacques Dupin: 'It may seem strange that the expression of the fantastic should break into

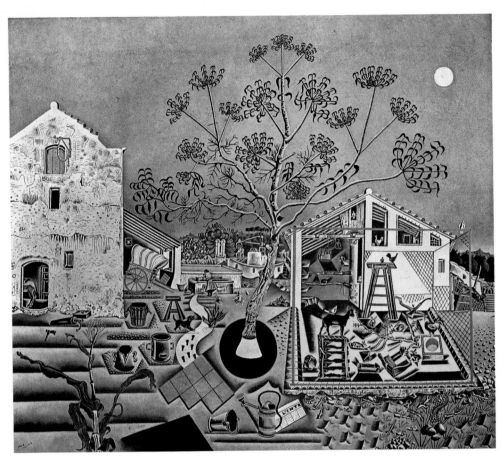

17 *The Farm* 1921–2

the work of Miró through the feet of the farmer's wife. But as Miró has said on many occasions, it is by the feet, and from the earth, that the energy that transfigures reality mounts.'[5] In his desire to penetrate to the essence of reality, Miró finds that contact with the earth and its magnetism is a factor as important as perception through the other senses. It is simple, banal and yet at the roots of our understanding. He has known through-

30

out that it is from terra firma, the sun-bleached soil, with its appetizing scent of plants, its dust, mud and weatherworn rocks, that we enter and enjoy the great open spaces, the all-invading light of day and the coolness of the stars by night. Just as the permanent foundation of the ground provides the springboard for voyages into outer space, so it is with the more mysterious flights of the imagination.

18 *The Farmer's Wife* 1922–3

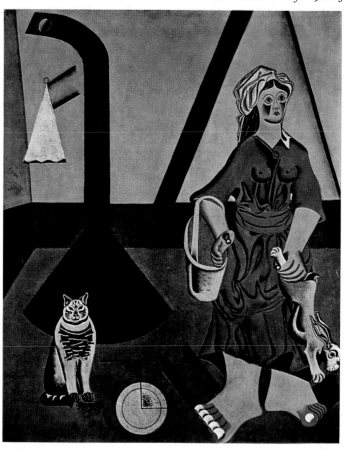

Paris and surrealism

From 1920 onwards, Miró worked during his winter visits to Paris in a studio in the rue Blomet which had been found for him by Llorens Artigas. In 1921, a small exhibition was staged at the Galerie La Licorne, with canvases from the Galerías Dalmau. This exhibition had the distinction of a preface by Maurice Raynal, but even so it was a complete failure.

It was in the rue Blomet, in 1922, that Miró made the acquaintance of André Masson, whose studio was separated from his only by a partition. Masson was to leave a lasting impression. 'Masson', he tells us, 'was always a great reader and full of ideas. Among his friends were practically all the young poets of the day. Through Masson I met them – through them I heard poetry discussed. The poets Masson introduced me to interested me more than the painters I had met in Paris. I was carried away by the new ideas they brought and especially the poetry they discussed. I gorged myself on it all night long – poetry principally in the tradition of Jarry's *Surmâle....*'[1]

Masson was closely involved with a group of young revolutionaries. Their ideas, which were concerned with the arts and politics in the widest sense, led them inevitably to unite with André Breton, Paul Eluard and Louis Aragon who were at that time bringing surrealism into existence; Breton recorded later that 'the tumultuous entrance of Miró in 1924 marks an important point in the development of surrealist art'.[2] Although the word 'tumultuous' would seem inappropriate when applied to an artist who has always been known to his friends as shy, reserved and taciturn, we can gather from its use here the impression made on the French poet by this young Catalan, illuminated by the fire that sprang from the inner forces of his

imagination and producing work that was strangely original and disturbing in its power.

The revolutionary activity which was astir among this group of young poets and artists who had lived through the misery and disillusionment of the First World War had coincided with a deep conviction in Miró that there was an urgent necessity to discover new methods and new ways of life. The dadaists, with whom he had come into contact both in Barcelona and in Paris, had thrown their insults at the conventional conceptions of art that belonged to a social system which had confirmed its hidebound inadequacy, but their destructive ardour eventually became tedious for those who wished to penetrate deeper into the fundamental nature of inspiration and the arts. The result was surrealism.

Among his new friends, those with whom Miró found himself particularly in sympathy were Michel Leiris, a scholarly, introspective poet and anthropologist with a love and understanding of primitive rites and exotic forms of art; Robert Desnos, poet and ardent explorer of the dangerous labyrinths of hallucination and hysteria; and the disconcertingly brilliant actor Antonin Artaud, who declaimed his hatred of organized religion in exultant prose and called for a determined blow for the liberation of the spirit. 'Abandon the caverns of existence. Come, the spirit breathes outside the spirit. It is time to leave home. Surrender to Universal Thought. The Marvellous is at the root of the spirit.'[3]

Before this outburst the new attitude had been more clearly formulated by André Breton in the first *Manifeste du surréalisme*, published in 1924. In spite of violent arguments the surrealists had arrived at an agreement that art is valid only when it has an equivalence with reality. They claimed that since all attempts at a logical analysis of reality had failed, the approach to a deeper understanding of consciousness should be, as Freud had already stated, through the subconscious.

The turbulence that emanated from the activities of the surrealists during these early days was to the outside world its

most obvious characteristic. But in addition to their determination to assert the capital importance of art in human society, Miró greatly appreciated their insistence on creating a fusion between poetic and visual imagery, and their belief that every effort must be made to widen the scope of our perception. With this in view, it became necessary to explore by every possible means the unfathomed realms of the subconscious. Dreams, hallucinations, even hysteria and madness were the obvious paths that must be followed in order to penetrate unhindered beyond the recognized frontiers.

Some years later, Miró explained to Yvon Taillandier how these views had affected him. 'I liked surrealism', he said, 'because the surrealists didn't consider painting as an end. With painting, in fact, we shouldn't care whether it remains such as it is, but rather whether it sets the germs of growth, whether it sows seeds from which other things will spring.'[4]

The subversive impact on Miró of these ideas, in combination with his natural tendency towards searching self-criticism, began at once to be seen in his work. A painting that he produced in the winter of 1923–4 called *The Ploughed Field* might have been expected to be the direct sequel to *The Farm*, but we find in it a very different approach to reality. Here the world of the imagination has become supreme. He presents us with a phantasmagoria in which ears and eyes grow on trees and the beasts of the field take on new and disproportionate shapes. Miró explained later that he had managed to escape into 'the absolute of nature', and that his landscapes have 'nothing to do with external reality'. 'They are nevertheless', he said, 'more essentially Montroig than if they had been painted from nature.'

From this time onwards, the mainspring of Miró's vision comes from a new source. It is by the eye of the imagination that he is guided, and it provides him with an inexhaustible abundance of images. His confidence in this new approach was strengthened by the surrealists' belief that the visions of the imagination must be counted as part of reality. Their argument

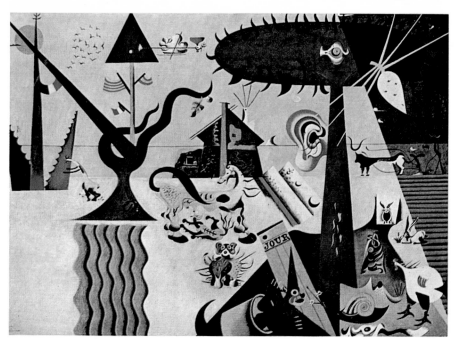

19 *The Ploughed Field* 1923–4

20 *Harlequin's Carnival* 1924–5

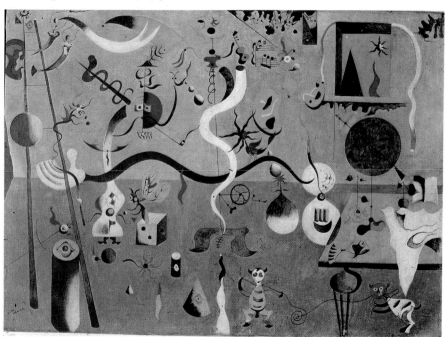

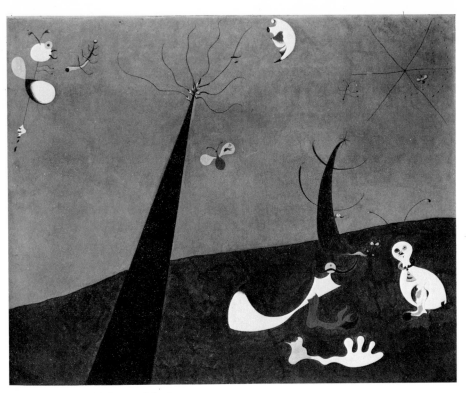

21 *Dialogue of the insects* 1924–5

was that used by William Blake, that 'what is now proved
was once only imagined'.

Between 1922 and 1925 Miró's work continued to develop
with a wealth of invention in form, and with the same exquisite
attention to detail. The knowledge he had gained from his
study of insects, fish, birds, and all the extravagant invention
20 of nature, was translated into paintings such as *Harlequin's*
21 *Carnival* and *Dialogue of the insects*, both of 1924–5. These pic-
tures become a riotous playground in which the size and shape
of each object or creature is adapted to give it the precise
movement and the characteristic expression Miró desires. But
with his childlike enjoyment of disproportionate limbs and
features, and his entirely personal sense of which colours are

36

appropriate, Miró exercises a decisive control, with the result that his extravaganzas become a miraculously well-ordered dance. Concealed in their movement, we find a strict rhythm which unifies form and colour throughout the canvas.

But the process which gave birth to these works was extremely arduous. 'For *Harlequin's Carnival* I made many drawings', he tells us, 'in which I expressed my hallucinations brought on by hunger. I came home at night without having dined and noted my sensations on paper. That year I often frequented poets because I felt I must get beyond *la chose plastique* to reach poetry.'[5]

It was probably the capricious fantasy of paintings such as *Harlequin's Carnival* that earned for Miró the reputation of being frivolous and even childish. 'Gaiety, sunshine, health – colour, humour, rhythm: these are the notes that characterize the work of Joan Miró' was to be the opening statement in James Johnson Sweeney's catalogue for the first important Miró exhibition in New York in 1941.[6] Although a childlike fantasy, an innocent sense of humour and an eager enjoyment of the grotesque have never abandoned him, there is even in these early works a poetic power, a precision, and an intensity in colour, form and every detail which remove them from the naïve and the trivial. They carry us beyond our first interpretations of their meaning into associations and analogies which can evoke unprecedented and significant discoveries.

Another of the paintings of the early 1920s, *Catalan landscape* **22** *(The Hunter)*, of 1923–4, is an example of the inventiveness of Miró's pictorial language and the originality of his sense of humour. Some of its cryptic signs are delightfully understandable, others keep their secret. The thought which has resulted in a particular fantastic shape is sometimes relatively easy to trace. For instance we recognize the bearded head of the hunter from his bristling moustache, his keen eye, his large attentive ear and the delicate curve of his pipe, although the shapes and the placings of these features are unnaturalistic. In the same language of signs we are given the clue to his body and legs,

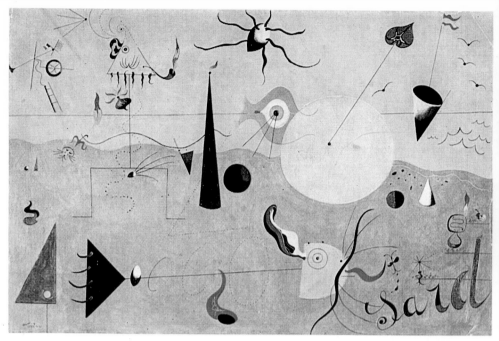

22 *Catalan landscape (The Hunter)* 1923–4
The Museum of Modern Art, New York

which are indicated by angular lines, and the curve of his arms, in which he holds on one side a dead bird and on the other a long conical shape which we recognize from the flame it emits as his gun. In the foreground is his quarry. The shape of its head and ear suggests a rabbit, but its body is reduced to a long straight line encircled by dotted lines and finishing in a triangular fish-like tail. There are other attributes to this ambiguous creature, shapes which evoke in a kind of visual shorthand the internal organs, just as the heart of the hunter all aflame is also clearly visible; the long flourish of a tongue reaches out from the rabbit's head towards a winged insect. These fragmentary signs are accompanied by the first four letters of the name of the traditional Catalan folk-dance, the *sardana*, splendidly inscribed in the foreground. This all adds up in simple terms to a poem inspired by the bucolic pleasures of a Catalan peasant who

lives between a sunlit winter sky and a warm rose-coloured soil.

The Hunter is an example of Miró's ability to invent his own language of signs. During this early period the interpretation of the symbols can often be literal; each factor acts its part in the scene, united with the others by bonds which are often implied rather than made visible. The whole composition is held together by the unity of the background and the visual rhythm set up by the signs themselves as they lead the eye from one point to another.

In the *Portrait of Madame K* (1924) Miró dismembers the *23* female form in the same way as he dislocates both the hunter and his prey. With a deliberate disregard for objective appearances and scale, he selects details which emphasize the presence of a woman. The picture is in monochrome; a mixture of oil and bold lines in charcoal makes a strong contrast with the pale, unadorned background. It is easy to recognize the basic elements of the female form: head, breasts, heart and the spinal column which finishes in an inverted arrowhead decorated with flame-like wisps of pubic hair. But in addition there are other signs which remain enigmatic, and which again provide a dream-like atmosphere in which the imagination is given its freedom. There is here a provocative gap between the precise delineation of Miró's signs and our interpretations, but if we accept that there is no need for a literal translation, and recognize that he is speaking in terms of subconscious visual sensations which have their own indecipherable reality, we can then enjoy them just as we enjoy the inexplicable construction of a flower.

The language invented by Miró in this painting creates a symbol which, I would claim, has a validity parallel to that of the word 'woman'. Indeed, it evokes an image of even more universal significance, since the understanding of a word is limited to those who speak one language. The word 'woman' is a sign which has great prestige, and with which we are very familiar, but it is after all no more than a sequence of sounds or

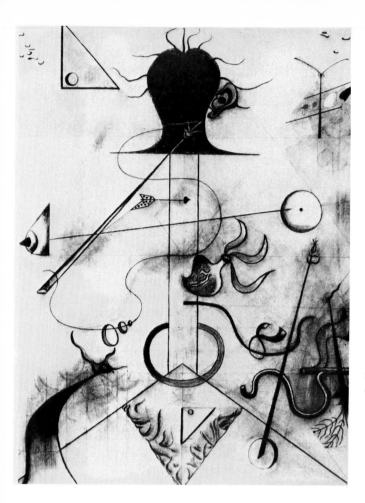

23 *Portrait of
Madame K* 1924

letters which separately have no apparent analogy with the
idea of woman and which to an Eskimo mean nothing. Miró
creates an aspect of reality in visual form, in which each
syllable has an authenticity comparable to that of the word,
but richer, and eventually more widely understood.

24 In *The Family*, painted in the same year, and also in mono-
chrome, some of the same symbols are used in a composition
which is complicated by the presence of three figures, father,
mother and son. A third painting of singular importance,
25 *Maternity*, is also closely linked with the *Portrait of Madame K*

40

and *The Family*. There is an obvious similarity in the woman's head, which is represented by a simple black shape crowned with hair radiating from it, but otherwise the symbols clearly defined on a pale blue background have become more cryptic. The body of the mother is condensed into a black conical shape pierced by a round hole. It appears to swing like a pendulum hung by a thin straight line from the head, while two small embryonic creatures, potentially human, climb towards shapes which we recognize as the woman's breasts. One breast is seen in profile and the other as a circle which could also be an eye or even the sun. Between them a shape, fish or spermatozoon, swims through the all-enveloping ether. There is an obvious resemblance between these small eager creatures and parasites that cling like children for food and protection to a parent body. Marcel Jean points out that 'many of Miró's paintings appear indeed to be portraits, sometimes burlesque, but more often menacing, of parasitic insects considerably

24 *The Family* 1924

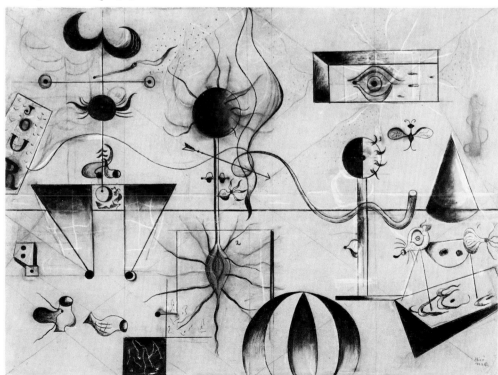

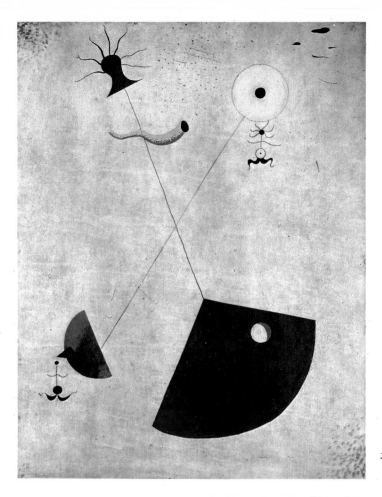

25 *Maternity* 1924

enlarged'. In *Maternity* 'the movement towards the breasts is still tentative, but we feel the force of attraction; elsewhere we shall find that Miró uses this fundamental force, this suction, to imply tension. The oral attachment of rudimentary organic forms is to be found frequently creating a sensation which is both attractive and repulsive to us but inevitably compulsive.'[7]

This picture is of interest because it demonstrates a further development in Miró's use of symbols. Renouncing the diversity of images and detail with which he had enjoyed

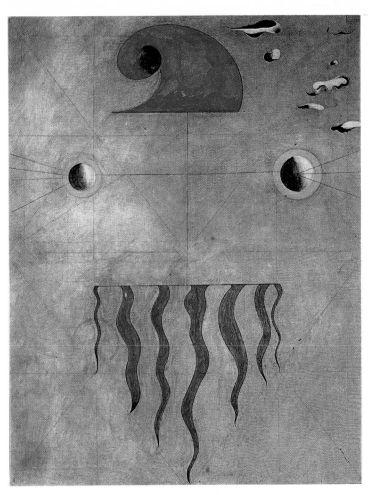

26 *Head of Catalan peasant* 1925

enriching earlier paintings, here he uses signs with strict economy and places them in a significant relation to each other. They are so linked and move so inevitably together that they have an organic unity, becoming a single anatomy that floats in a clear luminous element. This complex taken as a whole produces a new visual image of maternity which evokes in us deep reactions and a wealth of associations. It brings with it the conviction that we are approaching a new or perhaps very primitive sense of reality.

43

In 1923 Miró had exhibited in the conventional atmosphere of the Salon d'Automne with some other Catalan painters. In the same year he made the acquaintance of Ernest Hemingway, Jacques Prévert and Henry Miller. Hemingway later became the owner of *The Farm*, a painting which he declared years later he would exchange for no other in the world. This sale, brought about largely through the efforts of Miró's friend Jacques Viot, was the beginning of a much-needed relief from the poverty in which Miró had been living, and for the next few years a modest prosperity slowly came his way.

Miró also found in Pierre Loeb a dealer who was convinced of his talent, and in 1925 an exhibition at the Galerie Pierre brought the first considerable success, although it was founded largely on curiosity and scandal, a contribution to this being the preface to the catalogue by the surrealist Benjamin Péret. Over the next few years, a continuous showing of surrealist painters selected by Pierre Loeb gave Miró the opportunity to exhibit his 'dream paintings' in this gallery. In March 1926 the new Galerie Surréaliste advertised Miró as one of its artists in a list which included André Masson, Yves Tanguy, Giorgio de Chirico, Man Ray, Rrose Sélavy (Marcel Duchamp), Francis Picabia, Georges Malkine, Pablo Picasso and Max Ernst. In these two neighbouring galleries the most recent paintings of Miró were always on view.

The path that Miró had taken, which led him to draw increasingly on the subconscious, was bringing about a new crisis. A reaction against the pictures composed of isolated details encouraged him to banish such complications from his painting in favour of a more simple statement. The change is perhaps more strikingly expressed in a picture of 1925 which consists simply of an oval shape painted in blue on the bare white canvas. Crossing it in bold calligraphy are the words
27 *Photo/ceci est la couleur de mes rêves*; 'This is the colour of my dreams.'

44

By the winter of 1924–5 Miró, while absorbing many surrealist ideas, had begun to assert a very personal influence among the surrealists. After the culmination of his early work, in *The Farm*, he had developed a new lyrical freedom, but with 17 characteristic rigour he demanded of himself a clarification of purpose which can already be seen in *Maternity* and which he 25 proceeded to carry further, urged on by the surrealist appeal to explore the depths of the subconscious.

At an early age Miró had understood the necessity for a continuous questioning of his own achievements. He has said: 'Above all, never let a holy disquiet be lacking', and he tells us, too: 'When I was not content with my work I banged my head against the wall.' A study of his sudden changes of style and the challenges he has set himself will convince us that the apparent tranquillity with which he works is the surface tension necessary to contain the enthusiasms and agonies that are continuously at work in the depths of his thought.

The surrealists had helped to stimulate his ideas and suggest new methods of externalizing the riches of his inspiration. In their view it was important to explore not only the subconscious but also chance. The surprises which chance happenings could contribute to works of the imagination had been demonstrated first by Marcel Duchamp, and soon after by Max Ernst. It can be said that, since these early discoveries, chance has gained the reputation of one of the great impresarios of our time. Even so, it is the ability of the artist to recognize the peculiar virtues of the gifts he receives by chance that allows them to become significant. Paradoxically, with increasing skill and the assurance of a magician, Miró has gained a mastery over the uncontrollable, and he works in harmony with the unpredictable. Achievements such as these, which came naturally to him, won for him Breton's statement: 'He may be considered the most surrealist among us.'[8]

The subconscious, which acts from within, and which is subjective just as chance is objective, was examined with great enthusiasm by the surrealists. Encouraged by the doctrines of

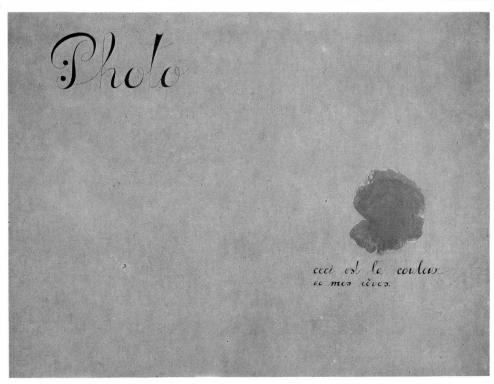

27 *Ceci est la couleur de mes rêves* 1925

Freud, they made extensive experiments in automatism, deliberately suspending conscious control in order to release an unhindered flow of subconscious thought. Among the poets who made the most thorough research into the sources of inspiration, encouraging states of hallucination and risking madness, were Miró's friends – Robert Desnos and Antonin Artaud.

In his search for a new visual language Miró entered willingly, as in paintings such as *Head of a pipe-smoker*, into the conscious attempts of the surrealists to liberate the subconscious; but his independent, taciturn character helped him to realize that such activities could only be a more or less successful means to an end which could be sensed rather than defined: the liberation of the spirit.

Ever since his arrival in Paris he had soaked himself in the works of the French poets, Rimbaud, Lautréamont, Jarry, Apollinaire, the precursors of surrealist ideas. 'As a result of this reading', he said, 'I began gradually to work away from the realism I had practised up to *The Farm*, until in 1925 I was drawing almost entirely from hallucinations. At the time I was living on a few dried figs a day. I was too proud to ask my colleagues for help. Hunger was a great source of these hallucinations. I would sit for long periods looking at the bare walls of my studio trying to capture these shapes on paper or burlap.'[9]

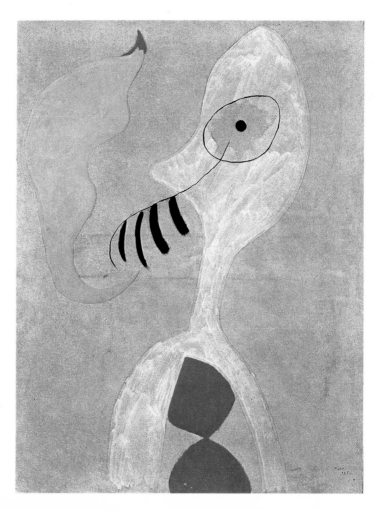

28 *Head of a pipe-smoker* 1925

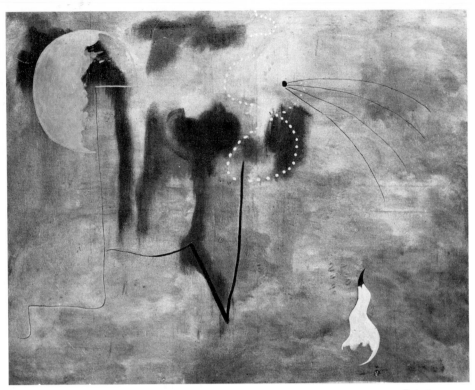

29 *Painting* 1925

The canvases that now followed have been called 'dream
paintings', not because Miró was painting from memory
what he had dreamed, but rather because they had their origin
to a large degree in the subconscious and were executed with the
greatest possible spontaneity. This approach corresponded to
the experiments of the surrealists in automatic writing and the
random choice of pictorial images; but Miró's originality
was sufficiently strong to make his 'dream paintings' a new and
revolutionary form of expression. This happened chiefly
because of his ability to eliminate elaborations and additions
introduced by conscious control; suppressing even the symbols
that were later to reappear with new significance, he arrived
occasionally at pictures which, stripped of all irrelevances,

48

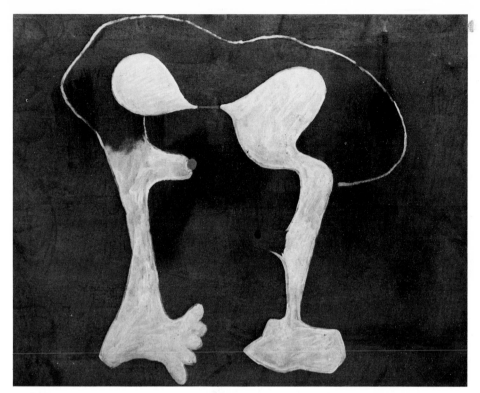

30 *Lovers* 1925

relied on a small spot of colour against an atmospheric back-
ground to give a sensation of infinite depth. This kind of
abstraction, which gives a sense of space without the aid of
geometry, created the elemental conditions in which Miró
could situate forms that floated freely or were held in a state of
tension in relation to each other.

Even in those works most thoroughly stripped of recogni-
zable signs, such as *The Birth of the World* (1925), we realize *31*
that the things we see are not vague abstractions. These paint-
ings convey the impression of a mysterious cosmic event.
Apparently incompatible bodies float in an ether, liquid or
gaseous. They seem to be drawn together in spite of themselves,
and their inevitable meeting seems to signify some imminent

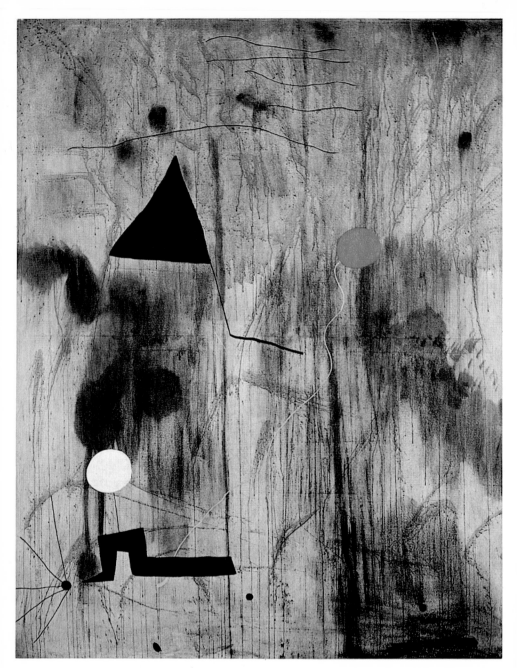

31 *The Birth of the World* 1925

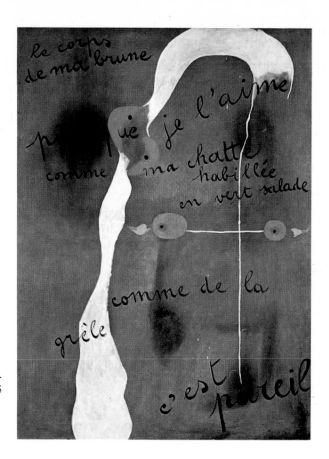

32 *Le corps de ma brune . . .*
1925

disaster or revelation. Yet all this happens without pretension. The forms are rudimentary and their colours unadulterated; often they are reduced to the simplicity of white or black. But it is the background, alive with the subtleties of chance happenings and creating an all-enveloping atmospheric distance, which sets the stage for dream-like encounters, striking up a compulsive dance among forms so incongruous that nothing but forces beyond their control could attract them towards each other. But, again, Miró never allowed his sense of humour and his delight in the absurd to leave him, as may be seen in works such as *Lovers* and *Figure and horse* (*The Gendarme*), of 30
1925, and numerous drawings of the same period. Once more

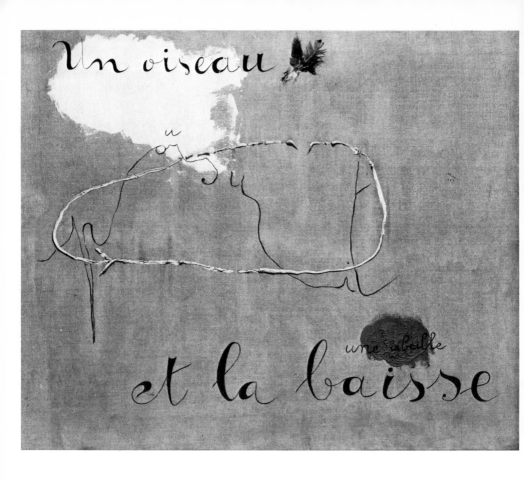

his conviction that he must keep his feet on the ground in order to reach transcendental heights saved him from vacant forms of abstraction.

In the 'dream paintings' of 1925–6 there is great restraint in colour and an elimination of the overcrowded descriptive details of earlier years. Instead we find, in general, linear signs reminiscent of the graffiti by which tramps make known their clandestine movements. These are combined with clearly defined flat shapes, spectral forms which in spite of their lack of representational qualities somehow obtain a life of their own. Their signification is often ambiguous. Some of them have biomorphic references, whereas others are so far abstracted

33 *Un oiseau poursuit une abeille et la baisse* 1926

34 *Amour* 1926

from their origins that we relate them more easily to the mysterious images that appear in states of semi-consciousness. At other times Miró intensified the enigmatic poetic significance of his paintings by the startling appearance of a number, a word or a phrase. Developing a technique which owed much to Apollinaire's *calligrammes*, and which had been used more recently by Max Ernst, Miró produced poem-paintings such as the large canvas with a rich brown background, *Le corps de ma brune...* of 1925, on which he wrote in powerful calligraphy across symbols of breasts and hair: *le corps de ma brune/puisque je l'aime/comme ma chatte habillée en vert salade/comme de la grêle/c'est pareil* ('my brown girl's body/since I love her/like

32

53

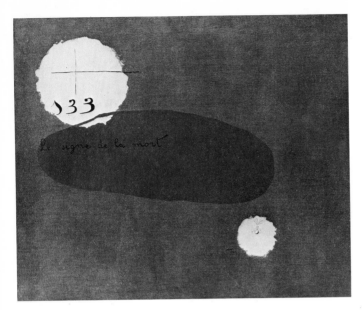

35 *Le signe de la mort*
1927

36 *Dog barking at the moon* 1926

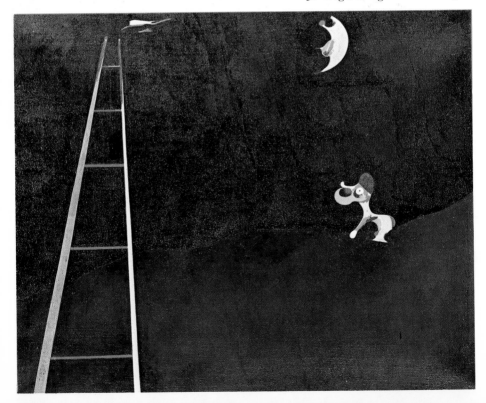

my she-cat dressed in salad-green/like hail/it's the same'). In
the 1926 painting *Un oiseau poursuit une abeille et la baisse* [*sic*] *33*
('A bird pursues a bee and lowers [ravishes] it'), the word
poursuit is given the eccentric course of the bird's flight; in
Amour (1926), a large shape like a head is embraced by the letters *34*
of the word *amour* starting from a small round mouth and
finishing with two small anthropomorphic signs, the male
climbing upwards in pursuit of the female.

His messages are not always light-hearted. Miró has the
ability to strike a note of terror with the most elementary
means, as in the small painting of 1927 where, on a patch of
bright red with the plain canvas as its background, he has
written *Le signe de la mort*, 'The sign of death', an announcement *35*
made strangely dramatic by its link with the white circle above
it which is crossed out with two thin lines and inscribed with

37 *Person throwing a stone at a bird* 1926

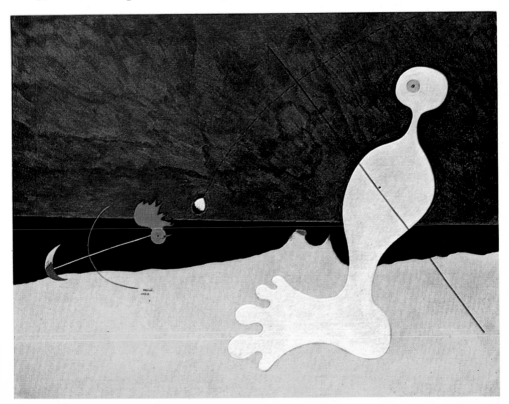

the number 133. There is no monotonous formula; in other
36 paintings such as *Dog barking at the moon* and *Person throwing a*
37 *stone at a bird*, both of 1926, no letters or numbers are used. The
forms are closer to the more representational figures of earlier
work, with brilliant touches of colour like small flames breaking
out at vulnerable points. There is no longer any definable
difference between the representation and the symbol.

In 1927 Miró left his friends in the rue Blomet to move into a
studio that had been offered him by his dealer Jacques Viot, in
the Cité des Fusains in Montmartre, rue Tourlaque. On the
door he put up a sign he had found in a shop saying TRAIN
PASSANT SANS ARRÊT, 'Train passing non-stop'. In this back
street bordering on a cemetery he again found himself sur-
rounded by a colony of surrealists who lived in adjoining
studios. His neighbours were Max Ernst, René Magritte, Jean
Arp and that sensitive creator of enthusiasm, the poet Paul
Eluard, who gained Miró's lasting friendship by the warmth
of his nature and the clarity of his thought.

Among the painters it was Arp who, in the detachment of
his character and in the style he had evolved, resembled Miró
most closely. As early as 1916 Arp had produced coloured wood
reliefs. The shapes he used were 'biomorphic' abstractions of
natural or commonplace objects in simple flowing curves,
impregnated with an astringent sense of humour. There is a
close parallel between them and the 'dream paintings' of Miró.
We know how they enjoyed each other's company, and even
the poverty they shared, 'eating radishes and butter', and it has
been suggested that Miró was strongly influenced by Arp.
However, Marguerite Hagenbach, Arp's second wife, told
Sam Hunter in 1958 that 'Arp would say that you cannot
really speak of influence, though, of course, Miró was im-
pressed by certain signs and symbols of Arp and perhaps used
some of them in his personal way.'[10]

Although there is a similarity between the shapes we find in the work of both artists, there is an important difference in their approach. Whether using his favourite technique of making configurations and arrangements formed by chance, or employing more deliberate methods, Arp was searching for a new aesthetic of form. His 'inarticulate form-experiences', of which Herbert Read speaks, become 'none the less significant at an unconscious level of the psyche',[11] whereas Miró's forms have a more directly symbolic value. Arp was therefore justified in affirming that 'the signs of Miró are closer to those of Catalan folklore and children's symbols'.[12]

Apart from stylistic affinities, Miró also was impressed by the earlier activities of Arp. In Zurich during the war Arp had been, with Tristan Tzara, one of the most brilliant and provocative initiators of Dada, and had followed this up by collaborating with Max Ernst in Cologne in 1920, when the scandalous Dada exhibition they organized was closed down on the orders of the occupying British authorities. Despite his reputation as a revolutionary, however, Arp disclosed the underlying serenity and seriousness of his character when he wrote years later: 'We were seeking an art based on fundamentals, to cure the madness of the age, and a new order of things that would restore the balance between heaven and hell.'[13]

Max Ernst had been a close friend of Arp for many years, having shared with him the rebellious scorn of the dadaists before tempering his bitterness in the more creative spirit of surrealism. There was in Ernst, however, a malefic humour which estranged him from Miró. The underlying rivalry between them was accompanied by a keen interest in each other's work. Living at such close quarters, the shy withdrawal of Miró and the more extravert vitality of Ernst resulted one evening in a long-remembered event which could have ended in disaster. Ernst, with his usual generosity, had shown Miró all his most recent work, including the new methods of collage and frottage which were then his latest inventions, but

Miró was reticent. He told Ernst that he had been warned by his dealer that no one must see his paintings before his next exhibition. Ernst's annoyance came to a head one evening when he had some surrealist friends with him in his studio. The lights fused, and, reduced to three candles, they sat drinking and watching Miró, whose lighting was unaffected, continuing to paint on the floor below. After a while, enticed by the light, Ernst and his friends made a surprise descent on Miró, who welcomed them and added to their high spirits with lavish quantities of wine from Montroig. With such treatment Ernst's overwhelming desire to see the paintings that surrounded them, turned to the walls, broke its bounds. With the help of his companions he proceeded to uncover all Miró's secrets. Becoming increasingly more aggressive, they finally invited Miró upstairs, where Ernst produced a rope he had used for mountain-

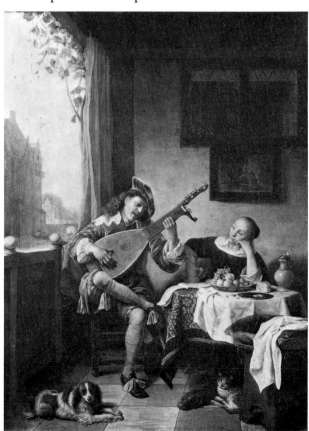

38 H. M. SORGH
The Lute Player 1661

39 *Dutch Interior I* 1928

climbing and, slinging it over a beam, placed a noose round Miró's neck in preparation to hang him. Questions were then put to Miró with sinister emphasis. 'Do you believe in God?' He replied evasively: 'I am not a philosopher.' Then, with more direct implication: 'Do you fear death?' He again replied: 'I am not a philosopher.' 'In that case,' said Ernst, 'if you are not frightened of death you are going to be hanged.' At a signal given by one of his friends, Ernst started to pull on the rope. But Miró's cunning was not only in his replies; he thrust his hands between the rope and his neck, and the noose slipped innocently over his head. With a sense of relief that the clowning had not finished in disaster, they allowed Miró to leave in a hurry; according to Ernst, he was not seen again for three days.

Boisterous behaviour of this kind could not, however, destroy the profound appreciation that both artists had for one another, nor did it rule out the possibility of working together. On the suggestion of Picasso, they had been invited in 1926 by Serge Diaghilev of the Ballets Russes to collaborate in designing the costumes and scenery for a ballet, *Romeo and Juliet*, with music by Constant Lambert. Their acceptance caused an abrupt reaction among certain surrealists, in particular Breton, who considered such activity to be frivolous and contrary to the serious anti-bourgeois principles of surrealism. As a result, and in accordance with the prevalent taste for agitation, there was a violent demonstration in the theatre on the first night. This was followed by a declaration signed by Aragon and Breton, beginning: 'It is inadmissible that thought should be at the command of money', which was published in *La Révolution surréaliste*, the review edited by Breton which had frequently reproduced paintings by both Miró and Ernst. It now denounced them for their 'attitude which provides the worst partisans of dubious morality with weapons'.[14]

However, thanks to the loyalty and the more discerning influence of Paul Eluard, the following issue of the review included paintings by Ernst and Miró again, with a declaration initialled by Eluard: 'It will be necessary once more for us to

recognize ourselves and our enemies, once more the latter must forgo their judgment of us. . . . We live in an atmosphere which for them is unbreathable. The most pure remain with us.'[15]

Eluard remained throughout his life an intimate friend of Miró. He was highly sensitive to the visual poetry in the work of his friend, and owned many of his paintings. Frequent collaboration between them culminated in 1958 in a rare and beautiful edition of Eluard's poem *A Toute Epreuve*, brilliantly illustrated with coloured woodcuts by Miró.[16]

The two years during which Miró was based in the rue Tourlaque came at a time when the early heroic period of surrealist activity was reaching its highest point of animation. The usual meeting-place, where lengthy discussions took place every evening, was in some chosen café such as the Cyrano in the place Pigalle, or the Café de la place Blanche. There was a continuous and lively exchange of ideas and projects covering a wide area from politics to new editions of poems, and embracing any idea, person or object that revealed some unheard-of peculiarity, or awakened a sense of the marvellous. Round the dominant presence of Breton, the progress and policy of surrealist activities was decided, exhibitions were planned, manifestos were written and signatures demanded. To refrain from signing was often interpreted as a lack of solidarity with the group, and at times this would be followed by a form of excommunication.

In their attack on classical aesthetic theories of ultimate or absolute beauty, it was probably Breton's emphatic statement that 'Beauty will be CONVULSIVE or will not be' that carried with it the most far-reaching implications. It heralded the violence that had suddenly appeared in 1925 in that great painting *The Three Dancers* of Picasso, and in his subsequent work; it became the basic attitude in all forms of surrealist expression and had an increasing effect on the work of Miró.

In contradiction to what may appear to be a tyrannical attitude when principles were concerned, the surrealists encouraged a wide variety of expression within the exceptionally

talented group of painters that had been attracted towards them. Unlike the production of former movements – impressionist, Fauve or cubist – whose artists can be identified by a certain 'family resemblance', the works of the surrealists, as Patrick Waldberg points out, 'are from the first differentiated to such a degree that not even a temporary confusion is possible between an Ernst and a Miró, for example, or a Tanguy and a Magritte. . . . What they do have in common, nevertheless, is the desire, overthrowing all barriers, to reach that 'beyond painting' that Max Ernst proclaimed as his goal.'[17]

A combination of Miró's retiring nature, his preference for solitude rather than the agitated company of his surrealist friends, and his admission of the value of diversity, made it possible for him to remain aloof and yet keep a close association with the surrealist group.

True to his habits, Miró returned every summer to Catalonia, and on 12 October 1929 he married Pilar Juncosa, who came from an ancient Majorcan family. On their return to Paris, Miró moved from the rue Tourlaque to a small apartment, 3 rue François-Mouthon, in a remote quarter where, owing to the financial slump which again reduced artists to very humble circumstances, he was obliged to work without a studio. Two years later their only child, a daughter, Dolores, was born in Barcelona.

The two years spent in the rue Tourlaque had been immensely productive. Miró had worked so hard that there had been little time free for visits to the café, but even so he had kept up contact with his friends among the surrealists. In the spring of 1928 he paid a short visit to Holland, where he became intrigued by the detailed realism of seventeenth-century Dutch genre painting. On his return to Paris, bringing with him postcard reproductions to remind him of the originals, he painted four pictures in which his own sense of reality forms a strange contrast with the commonplace realism of the Dutch masters. Although it is possible to trace the overall arrangement of the original works, the liberties taken by Miró result in a

completely new version. In *Dutch Interior I*, the dog, the 39
musician, the table, the cat, in that sober painting *The Lute* 38
Player by H. M. Sorgh, have been transformed with outrageous
humour into a vertiginous dance. Colour, form and the pro-
portions of each object obey Miró's orders and are held together
only by his masterly sense of design.

A brilliant picture of his, *The Potato*, also of 1928, had its 40
origin in a seventeenth-century painting of a woman. The
central figure is surrounded by the intense activity of small
lively forms in brilliant colour and precise detail, but their
fantastic diversity is held in control by Miró's sense of rhythm
and his ability to vary the scale of objects to fit his design and
his interpretation. For example, the smallness of the hand on
the left is contrasted with the monstrous growth of the hand
on the right, which has graven on its palm the pattern 'M',
which, besides having a religious connotation, is common to

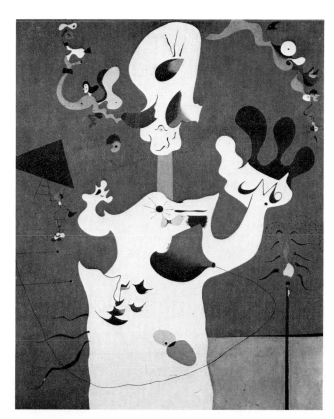

40 *The Potato* 1928

most hands and happens also to be Miró's own initial. *The Potato* here is both a woman and an image of the earth itself, the earth-mother and an object of devotion.

 Other portraits derived from artists of the past, such as *Portrait of Mrs Mills in 1750* after George Engleheart, are treated with equal freedom, although certain traces of the original are always present, like ghosts. The contrast between the sober realism of the original works and his own extravagant fantasy helped Miró to answer the question: ought we to oppose reality to fantasy, or are they complementary parts of the same totality? He was able to prove that, through fantasy, he could establish a valid aesthetic reality, understood and enjoyed as such.

41

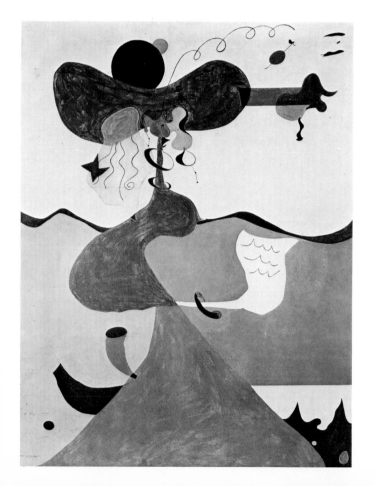

41 *Portrait of Mrs Mills in 1750* 1929

'Assassinate painting!'

In Miró's treatment of the Dutch masters there was an element of admiration, mixed with a touch of mockery at the pedestrian conception which underlies their search for reality. There seemed to be something radically absurd in an art which limited itself to a photographic resemblance dolled up with the artificiality of academic arrangement. The illusion which these painters were striving to create in the name of reality might be enjoyed, with a certain indulgence, but it contained a pitiful misunderstanding of the true meaning of art.

It was this feeling of profound dissatisfaction with conventional standards that had provoked the violence of the dadaists and caused Duchamp to add a moustache to the *Mona Lisa*. Miró was now to express it in his emphatic declaration that 'Painting has been in decadence since the age of the cavemen.' Rather than subscribe to the falsity of the contemporary attitude towards art, Miró declared that he wished to 'assassinate painting', and to prove he was in earnest he denied himself for a while the means of expression – paint and canvas – that he had shown he was able to use with such outstanding talent.

The 'dream paintings' of the mid 1920s had become insufficient as a means of expression for him. They had developed from the ideas and techniques of surrealism. The latent revolt in Miró, which had been incubating ever since his first contact with Dada, had not yet revealed itself sufficiently and now, by delayed action, was ready to explode.

The manner of the explosion was not, however, the extraverted blast of the militant anarchist. Miró's anti-art revolt was an inner, personal affair, in keeping with the slow contemplative movement of his own nature. The moment for this

outbreak arrived in the winter of 1928–9, and paradoxically the thoroughness with which he interrogated his own motives, and the discipline he imposed on his natural talents, led to new discoveries and a widening of his means of expression.

43 Having abandoned for a while the richness of oil and tempera paintings, he turned to collage as a medium which was less conventional and demanded a change of style. It also provided new opportunities to exploit chance encounters between objects and forms. The juxtaposition of unrelated objects had already become a surrealist technique; in Miró's hands the shocks produced in this way brought about a change in the nature of the objects themselves, a metamorphosis and a shift in our interpretation of their reality.

A subject close to Miró's heart has always been the Spanish dancer. The new variations he devised on this theme in 1928

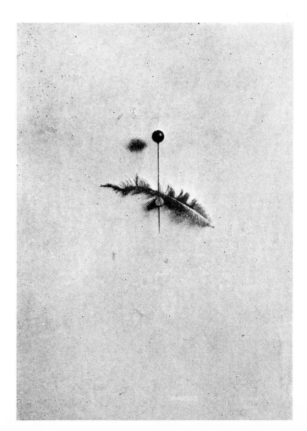

42 *Spanish dancer*
1928

66

are in themselves objects of extreme simplicity. Paul Eluard described one that pleased him particularly as 'a picture that one cannot imagine more naked. On a virgin canvas, a hatpin and a wing feather'; this was sufficient to astonish Eluard and to evoke a trail of erotic associations. Other versions went even further towards abstraction. They consisted of geometric shapes drawn or pinned on a plain background so that all signs of painterly skill have vanished. But it is important not to confuse this tendency with the intentions of artists such as Mondrian, who used abstraction as the basis of a new aesthetic. The difference here is that Miró's work was derived from a subject, the Spanish dancer. The process of abstraction he used had as its motive a revolt against the conventional aesthetic qualities required for a work of art. His aim was to evoke images by simple means, whereas Mondrian and his fellow abstractionists

42

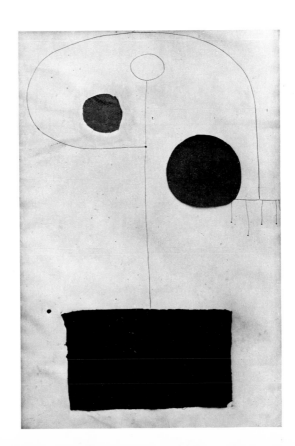

43 *Collage* 1929

were seeking to establish a new form of art according to the laws of aesthetics stated in geometric abstraction and divorced from all references to subject-matter. Miró was in fact invited by Mondrian to exhibit with his Abstraction-Création group and refused indignantly, explaining that he did not wish to join them in their 'deserted house'. 'As though', he told Georges Duthuit, 'the signs I transcribe on a canvas, since they correspond to a concrete representation in my mind, were not profoundly real, and did not belong to the world of reality!'[1]

44 His abstract constructions led to a series of collages into which he introduced the popular imagery of postcards, and which he often completed with line drawings. In these Miró showed for the first time his delight in using textured surfaces and his ingenuity in the choice of strange objects and materials. By a denial of his natural ability to exploit colour and form in the conventional way with paint on canvas he had discovered a new means of expression.

'If we ask: who is Miró?', wrote Ribemont-Dessaignes, 'we ask at the same time: what is painting?' The crisis that induced Miró in 1928–9 to abandon painting was another of those upheavals of the spirit that have continued periodically to challenge fundamentally his attitude towards art and, by implication, towards life in general. The 'assassination of painting' led him to turn his thoughts from the exquisite finish of his earlier work and to look for stimulus among objects of the lowest order. The metamorphosis that could be brought about by putting such things as a piece of old rope, or a rusty mattress spring, in contact with bright colours and painted figures of his own invention, was an act of creation worthy of his attention. Experiments such as these corresponded to his dissatisfaction with the time-honoured limitations of the picture-frame. The influence of the objects he invented could now be physically extended into the space round them. Also, a lack of concern with permanence offered a means of provoking an immediate reaction from the spectator. It was the beginning of an attitude which he described to Georges Duthuit in 1936:

44 *Drawing-collage* 1933

'As you see I attach an increasing importance to the content of my works. To me, rich and vigorous material seems necessary to give the spectator a blow between the eyes at first sight, which must hit him before other thoughts can intervene. In this way poetry expressed visually speaks its own language.'[2]

Many of the objects that Miró made at this time have disintegrated, as he intended, but enough have survived for us to be able to receive from them that shock which he claims is

69

45 *Torso of a nude woman* 1931

46 *Seated woman* 1932 ▶

an essential part of his visual language. In this way they are unlike the cubist objects of Picasso which, although they were fragile, relied on harmony of composition and coherence of meaning. They are also unlike the dadaist readymades of Marcel Duchamp, being, in surrealist terms, 'objects functioning symbolically' rather than 'objects of concrete irrationality'.

It was the gaiety and artful childishness of objects such as 105 *Man and woman* (1931) that seduced the dancer and choreographer Léonide Massine, and persuaded him to ask Miró to

design the costumes and décor of his ballet *Jeux d'enfants*, which was first performed in Monte Carlo the following year.

During the same period, about 1930, there was another new development – a series of oil-paintings on paper. The backgrounds are bright with large areas of luminous colour. Signs drawn with vigorous lines in works such as *Torso of a nude* 45 *woman* (1931) are mysteriously related to a transparent depth in which they float. The paintings gain their ethereal substance by a contrast between forms with a strong determined outline

and a luminous void, revealing a continuity with the earlier search for a sensation of limitless space.

Ever since Miró abandoned representational realism in the early 1920s he has tended to use flat surfaces of colour as a means of illuminating clearly defined shapes. But in some small 46 pictures painted on wood panels in 1932, he developed further a method by which the forms became interlocked and united in spite of violent changes of colour. As one shape passed across another, like the shadow of the earth during an eclipse of the moon, its colour changed abruptly. For instance, if a black square overlapped a red circle the area of their intersection would change, say, to yellow, thus giving a continuity and a transparency to both shapes. By this simple device it became possible to preserve an uncompromising brilliance of colour, and also to allow the shapes to remain unbroken. In addition, a sense of the third dimension appeared mysteriously in a strictly two-dimensional style.

This invention has been of great service to Miró. He has never used it as a rigid system, but with varied adaptations it has become one of the characteristics of his work. It evokes an experience which goes beyond purely aesthetic considerations. In it we find a statement of the mutual change that takes place when two shapes of different colour intersect each other. Unconsciously Miró was stating a natural phenomenon in his own terms. He was reversing the effect produced by applying layers of primary pigments to a white surface, which results in black. The luminosity of these 1932 compositions comes from his instinctive understanding that areas of coloured light projected on to a white surface produce white when they overlap. Miró had obtained with opaque colour the effect that is produced by the interaction of luminous colour.

Speaking of Miró's invention as a decision of genius, André Breton wrote: 'It seems to me that it is in the simplicity and the rigour of the form-colour relationship, thus totally re-created, that the absolute originality of works such as this and the secret of their affirmation on the organic plane resides.'[3]

The cubists had devised a means of preserving continuity in objects when otherwise they would logically have become hidden behind other objects. This inevitably introduces a sense of transparency, as it does in Miró's method, but his purpose is different. The cubists were preoccupied with objects which they wished to analyse and reconstruct according to a new conception. Miró is interested in presenting us with shapes which have organic implications, but which are only remotely connected with objects. We shall see later the astonishing metamorphoses that he brings about.

The small paintings of 1932 are knit together like a mosaic of forms in primary colours; the anatomical shapes of head, arms, breasts and body, although freely distorted, are still recognizable as signs. In the early spring of the following year, however, Miró embarked on a totally different path, which was to result in one of his most significant achievements and a major development of his style.

Working in a very restricted space in the attic of his home in the Pasaje del Crédito, he began by cutting out illustrations from catalogues of hardware, mostly minute but precise engravings of tools, machines and other merchandise. He then pasted these at random on large sheets of white paper. These collages, which in themselves have wit and the evidence of 49, 50 Miró's innate sense of composition, then became the models or the raw material from which he drew his inspiration. From them he began a series of great canvases whose dimensions were such that, owing to the lack of space in the attic where he worked, he could only keep one on its stretcher at a time.

The collages brought about a change of identity in the objects themselves. They were no longer a guide to purchasers. In their scale and their positions the illustrations now had no practical relation to each other at all. They forfeited their original, obvious connection with reality. But an even more astonishing metamorphosis was to follow, when Miró began to use these collages as models for his paintings. If we now 47, 48 compare the two, it is possible in each canvas to find clues from

the shape and meaning of each of the catalogue illustrations and
to trace references to their positions in the collage, although
Miró allowed himself complete liberty in the transformations
he made. There are occasionally definite signs, like wheels or a
rudimentary face or hand, that give clues to their origin, but
otherwise the transition from a hardware catalogue to the
mysterious signs in the paintings has become intentionally
very obscure.

 Of the great variety and the spontaneity of these paintings
47 there is no better example than *Painting* (1933), which belongs

47 *Painting* 1933 The Museum of Modern Art, New York

48 *Painting* 1933

49 Preliminary collage for *Painting* 1933 50 Preliminary collage for *Painting* 1933

to the Museum of Modern Art of New York. The collage in which it originated is composed of isolated pieces of engineering equipment scattered over a white sheet of paper. In every case Miró began his canvases by preparing a background in rectangular areas of sombre colours, purples or greens that merge into each other and give only a blurred sense of horizontal and vertical divisions. The forms he then superimposed appear to float, dance, or embrace, detached from the ground in an all-enveloping cave-like atmosphere. They have substance that suggests a shadow play of dancers performing a mysterious rite, or signs painted or carved on the walls of a cave by prehistoric man. It is a long cry between these evocations and the machines that sparked off Miró's collages, but there is no doubt that the shapes have now gained for us the status of symbols. The question remains, however: what connection do they have with reality? What, in fact, do they signify?

Miró tells us clearly that he never sets out with the intention of creating a symbol. How is it, then, that he can fascinate us by inventing what we might call abstract forms that appear significant and somehow related to prehistoric signs? The explanation, to me, lies in the relation of these forms to the fundamental shapes of organic nature, its growth and its movement, and to the attractions and repulsions that result in the perpetual reproduction of life around us. We find archetypal precedents, in simple fundamental forms such as the spiral, the circle, the triangle and the more anthropomorphic violin shape, in the earliest known works of art. But the symbol appears in the first place to impose itself rather than to be consciously created.

It is by virtue of his profound sensibility that Miró is able to communicate by means of symbols. In doing so, he resembles our ancestors who unselfconsciously created a language of art which speaks to us in a way that is timeless and universal. His forms, like theirs, act as an incitement to the imagination without being attached to a meaning. 'It is signs that have no exact meaning', Miró told me, 'that provoke a magic sense.'

The degree of power invested in these signs must, however, depend on the ability of the artist. When, like Miró, he possesses the sensibility of a magician, he can proceed by whatever means he may devise, and will be able to create living symbols which will establish a new communication between men and between man and the transcendental forces of nature – signs that give shape to our most compelling emotions: love, hate, confidence, fear.

The great canvases of 1933 are important apart from their content, as being some of the largest in scale that Miró had yet attempted, and as the source of a style which he was to develop in the great murals that followed. He found in them the path that was to lead away from the detail of his small-scale easel paintings to other media, such as tapestries and the ceramic murals that he was later to construct.

PEINTURES SAUVAGES

From a distance Miró had approved of the rebellious attitude of the dadaists towards society, but the surrealist revolution into which he had become absorbed after his first arrival in Paris was for him, primarily, an adventure in personal methods of expression. It was with reluctance on his part that he was at times drawn into the group activities of his friends, and it was not until the political climate began to deteriorate seriously, in the early 1930s, that a profound and violent reaction to political events took place in him.

In 1934, following the great compositions he had painted the year before in Barcelona, Miró made a series of pastels on special paper which suddenly spoke of new and terrifying experiences. The 'gaiety, sunshine, health – colour, humour, rhythm' which characterized his earlier work were transformed into a prophecy of the crescendo of horror that was to begin with the Spanish Civil War two years later. The biomorphic shapes in pure colour, which had moved in a rhythmic dance in the compositions of 1933, now became solidified into

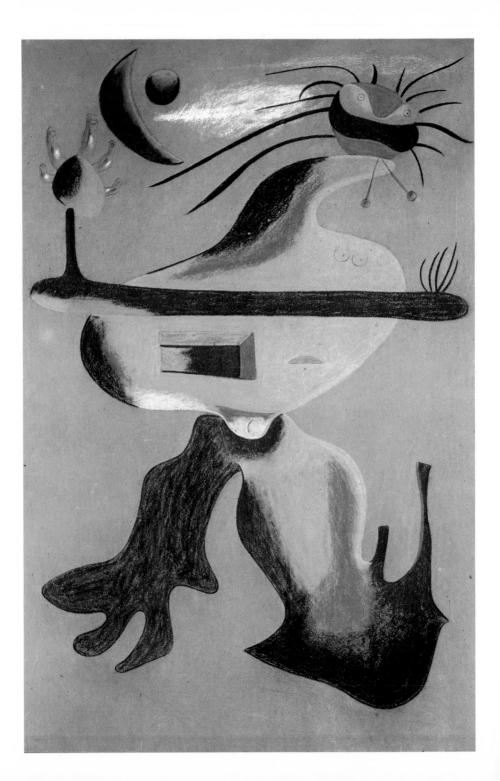

fierce embodiments of female monsters seen in brilliant colour. *51*
In this frightening mood Miró used the softness of pastel
technique to accentuate by contrast the fierce grimaces and the
violent distortions of the figures. Setting aside the discipline of
flat colours and shapes, he accentuated the roundness of the
forms with acid colours and soft gradations. The appearance
of this series of about a dozen pastels was the prelude to a long
and powerful succession of paintings to which Dupin has given
the name of *peintures sauvages*. It becomes obvious from these
pastels alone that Miró had been deeply affected by political
events over which he had no control and about which he was
compelled to unburden his disquiet.

In the paintings that followed, such as *Persons in the presence
of nature* (1935), instead of a lyrical delight in nature, reflecting *52*
the assured tranquillity of peasant life, which Miró had formerly
treated with roguish humour, we find a sinister foreboding.

◀ 51 *Woman* 1934

52 *Persons in the presence of nature* 1935

53 *The Farmers' Meal* 1935

54 *The Two Philosophers* 1936

55 *Two personages in love with a woman* 1936

The sky becomes loaded with red and black. Orgiastic, hys-
53 terical dancing in paintings such as *The Farmers' Meal* (1935)
20 supersedes the elegant ballet of *Harlequin's Carnival* (1924–5).
It is rare that an artist can sustain with such invention a pitch of
violence as acute as was now to be revealed. The paintings of
1935 and 1936 are small in size and many of them are painted
on copper with detailed clarity. In all of them we find a world
of conflict and absurdity inhabited by creatures of incredible
54 ferocity, even though their titles, such as *The Two Philosophers*
(1936), *People attracted by the shapes of a mountain* (1936) and
55 *Two personages in love with a woman* (1936), sometimes suggest
the contrary.

80

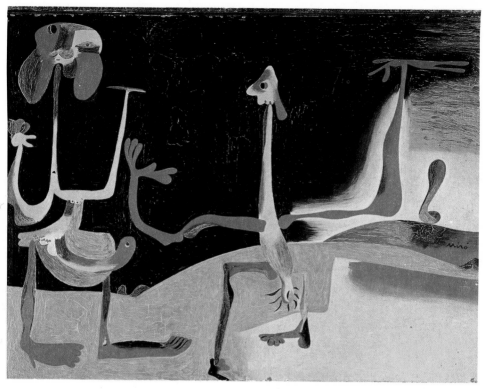

56 *Man and woman in front of a pile of excrement* 1935

However, one small painting typical of Miró's mood is given
56 a title which does not belie its content: *Man and woman in front
of a pile of excrement* (1935). A grotesque and gaudy couple
gesticulate in front of a black sky. Their apparent satisfaction
can only be due to a monument on the horizon, framed in an
aura of light, to which they point with pride, but which is no
more than putrefaction of their own creation. The fact that this
situation can be described in words does not diminish the
combination of mystery and nightmarish reality. The candour
and the bold accomplishment of Miró's statement miraculously
render the repellent horror and cynicism of this fable acceptable,
even enjoyable. The figures are stripped to their essential
significant features, and are impregnated with a humour so

82

57 *Two personages* 1935

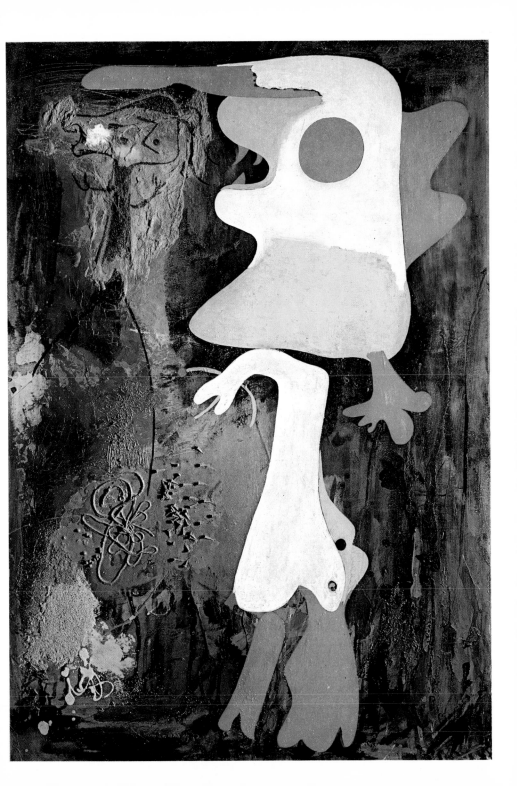

ferocious that they regain a primeval innocence. 'Miró's art', to quote James Fitzsimmons, 'offers one of those rare instances of a modern technique successfully adapted to primitive subjects. His sense of ancient mysteries, of the irrational, of magical powers that stand behind all things, forcing us to take a stand and accept the unacceptable, . . . comes through with exceptional vividness and power in these *peintures sauvages*.'[4]

The first group of small paintings was followed by other forms of expression in which the violence of Miró's feelings was expressed in a more abstract style: situations brought about by disquieting encounters between objects such as nails, knotted string, an old toothbrush, lengths of chain, a rusty bed-spring,

58

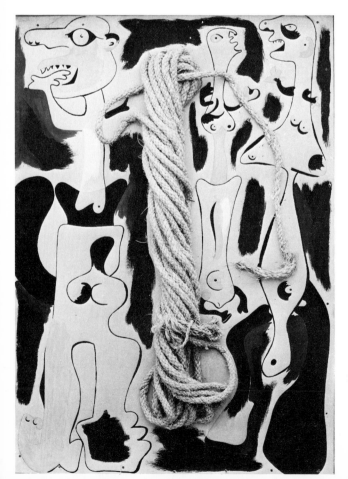

58 *Rope and people I* 1935
The Museum of Modern Art, New York

a gas-ring, a log decorated with erotic signs. With these insignificant pieces of scrap he achieved sometimes an expression of light-hearted surprise and at other times an uneasy sense of discord. A painting of April 1935, *Two personages*, is an example of Miró's power to intensify images by overriding aesthetic considerations and using unexpected materials – in this case sand, a piece of bark, a tangle of rope and other substances stuck to the picture.

In 1936 the Spanish Civil War broke out; Miró was not to revisit Spain until 1940. He now found it impossible to contain the disquieting marriage between charm and horror within the small dimensions of the exquisite paintings on copper, and switched abruptly to a very different manner, using large panels of masonite of uniform size. With coarse materials, casein white, tar, red ripolin, sand and gravel, he attacked his panels with vigorous gestures, relaying his emotions directly in a style which proved to be the precursor of 'action painting'. Spontaneous and obviously aggressive, they are indicative, in different terms, of the same inner torment which is expressed in the earlier paintings on copper. In his return to a more abstract form of expression, there is no slackening of tension or lessening in the vitality inherent in the signs.

Miró's means of expression are manifold, and the continuing anxiety caused by the Civil War made itself felt in 1937 in two other works of great importance: *Still-life with an old shoe*, a medium-sized painting, and *The Reaper*, a large mural.

It is evident from the *peintures sauvages* that Miró's apparent detachment, his constant refusal to take any active part in politics, was a defensive measure. Beneath his tranquil façade he felt acutely and almost with clairvoyance the sinister menace of fascist domination which was now attacking his own country. The *Still-life with an old shoe* is, in all his work, the most concentrated evidence of his attitude, and can in some ways, as James Thrall Soby (to whom it belongs) points out, be compared with Picasso's great expression of indignation in *Guernica*, painted the same year. Although they differ greatly

57

59

60
61

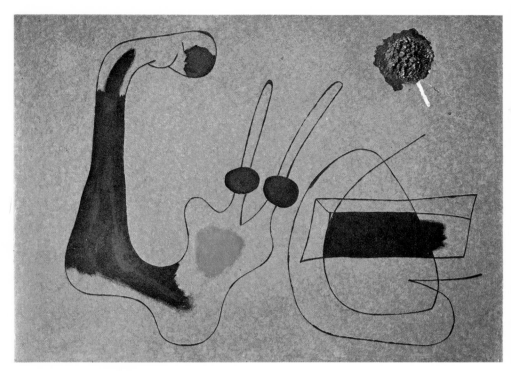

59 *Painting on masonite* 1936

in conception and in size, both paintings share a deep concern for the sufferings of the common people. Miró uses as his material the familiar essentials of life, an apple, a loaf of bread, a bottle of wine, an old shoe, seen in an atmosphere of catastrophe. Their shadows are thrown up on the clouds and mingle with the sinister colours of a great conflagration. Each object is given a dramatic interpretation. The apple is pierced by the relentless prongs of a fork which descends on it like an arm from the sky, the bottle in tattered wrappings is warped and blackened as though by fire, the half-eaten loaf is dry and unappetizing, and the old shoe has surrendered its usefulness in disintegration. As in all paintings of this series, unlike Miró's

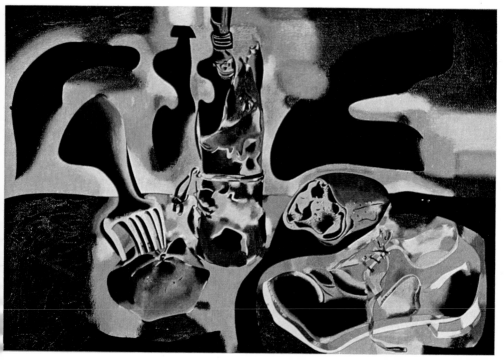

60 *Still-life with an old shoe* 1937

'dream paintings' and his later work, this calamitous situation takes place on the ground. The painting of this dramatic image of a world threatened by destruction was achieved by long concentration in the seclusion of a small room in Paris lent to Miró by his friend and dealer Pierre Loeb.

The Reaper was commissioned by the Spanish Republican *61* Government and painted in the summer of the same year. It was placed in the Spanish Pavilion designed for the International Exhibition in Paris by José Luis Sert, the Catalan architect who later built Miró's studio in Majorca and the galleries of the Fondation Maeght at Saint-Paul de Vence. Picasso's mural *Guernica* was also placed in the same pavilion, and near by was

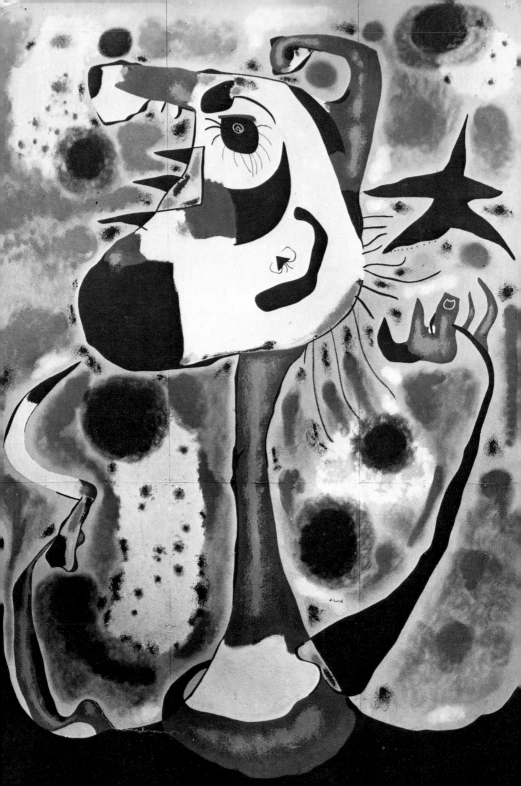

a *Mercury fountain*, the work of another friend, Alexander Calder. The theme of *The Reaper* was again the Catalan peasant, treated with an exuberant violence which does not exist in those pictures of the same subject painted in the mid 1920s. In this case, a great head in profile, seeming to shout defiance, grew like a plant from the soil, crowned by a crumpled Phrygian cap and surrounded by a tattered star and large circular spots like explosions.

At the same time Miró produced a silkscreen print, in brilliant colour, with the words *Aidez l'Espagne*, 'Help Spain', written boldly round the figure of a Catalan peasant raising an immense clenched fist. The price of the print, one franc for Spanish relief, was worked emphatically into the composition. All these public manifestations helped Miró to overcome his despair by presenting an image which is heroic, savage and not devoid of bitter humour.

26

62

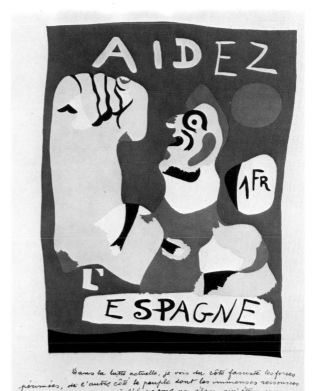

61 *The Reaper* 1937

62 *Aidez l'Espagne* 1937

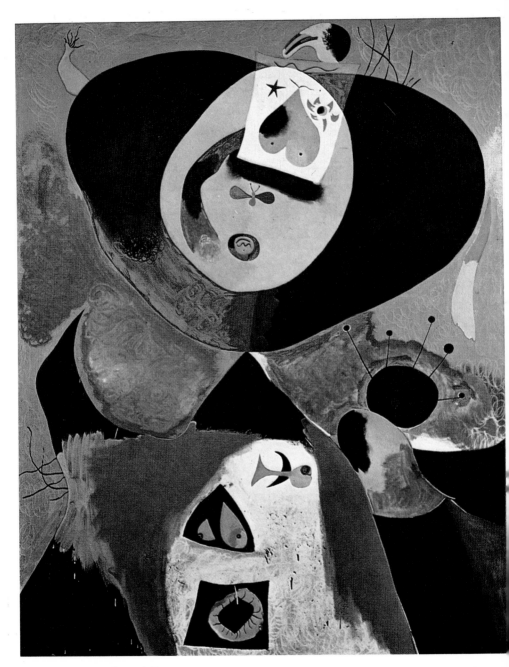

63 *Portrait I* 1938

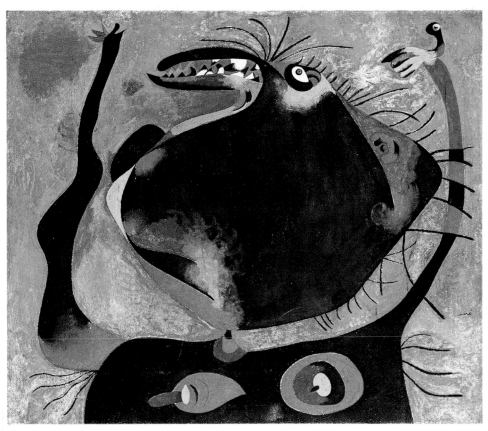

64 *Woman's head* 1938

As the Civil War continued, Miró discovered the means of
living with his inner anguish. Four large paintings, each entitled *63*
Portrait, of astonishing brilliance in colour, and with a wonder-
fully inventive sense of form and a gay accompaniment of
flaming suns and stars, were painted in 1938, as were other more
light-hearted and poetic works such as *Une étoile caresse le sein* *65*
d'une négresse ('A star caresses the breast of a Negress'). But
there are two paintings of the same year inspired by women,
Woman's head and *Seated woman I*, in which the full violence *64, 66*
of Miró's feelings again makes itself felt.

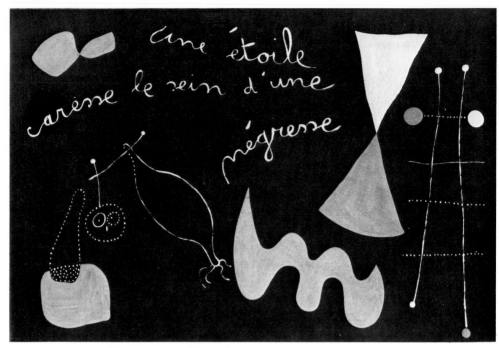

65 *Une étoile caresse le sein d'une négresse* 1938

There is a strange paradox in the contrast between the un-
failing devotion of Miró to his wife and daughter and the
extreme cruelty in the images of woman that he presents to us.
The predominance of female symbols throughout his work is
a clue to his preoccupation, but we never find him paying
conventional tributes to Venus. On the contrary, particularly
in the *peintures sauvages*, woman appears in a form which is
diabolical and grotesque, closely suggestive of a bird of prey
or a dragon, her attributes exposed like savage jewellery. Of
all these images *Woman's head* is one of the most extreme in its
violence. The blackness of the head, the ecstatic gesture of
the arms thrown in the air, the stare in the bloodshot eye, the
sparse bristling hair, the sharpness of the alligator teeth, the
comic flaccidity of the nipples that protrude like tongues from
open mouths, the combination of bird, animal and human

64

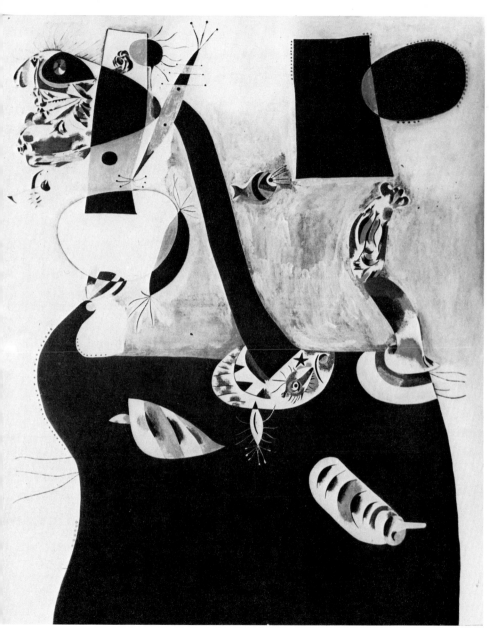

66 Seated woman I 1938

being, and all this rising up in a blaze of colour before a deep blue sky, is a terrifying image alleviated only by the buffoonery of its convincing presence – a cruel comedy, so virulent that it transcends personal reactions and becomes the mischievous hieratic emblem of evil, splendid in its outrageous violence and belonging to the realm of dreams or of the gods.

66 *Seated woman I* is a larger painting and again a fantastic image of mythical power. Like many of Miró's female symbols, the figure seems by the blackness of her form to belong to the night. Again the head is sinister and beast-like, and again there is great seduction in the fierce gaiety of the colour and in the eye-catching decoration of her breasts, which shine, isolated in the uniformly black shape of her body, as she bends threateningly towards us. By his savage wit Miró provokes us into reverence and admiration. Through his jungle of monsters we are led to the gateway of understanding. Miró knows intuitively what it is to be a woman. He invites us to feel delight and to cringe with terror, as we observe the female image, the form from which we emerge.

We find in these paintings, as we do throughout his later work, various metaphors for woman, by far the most frequent being the bird. There are some qualities common to both woman and bird that are seductive, like the softness of down, the lure of colour, the grace of movement in dance and in flight, and the enchantment of song. At other times their attributes are diabolic, taking the form of sharp claws, teeth or beaks, such as we find in harpies or medieval devils. For Miró the bird is also frequently a symbol of movement, of flight, permitting a transference from one element to another, from earth to air. It is a sign of the depth and boundlessness of space, a means of transcendence. Its significance is such that it is not possible to limit the bird metaphor entirely to the female aspect. It often refers in Miró's work to the male sexual act, as in the

33 painting of 1926, *Un oiseau poursuit une abeille et la baisse*, and in certain references to the swan with its long stretched neck and phallic beak.

94

The female, like the bird – *The Passage of the Divine Bird* is the title of the last of the wartime *Constellations* – has a fundamental connection with divinity. As the producer of life she is possessed of brilliance and authority. She finds her place among the elements, standing before the sun, the moon and the stars or with birds in the night, and she is equally powerful as a symbol of darkness and of death. In our self-destructive age her appropriate likeness is Kali bedecked with the skulls of her children.

Miró's entry into these regions is unpremeditated. His images spring directly from that universal realm described by Jung as the 'collective unconscious', rather than from any deliberate intellectual process of thought. Dupin adds: 'Miró finds again

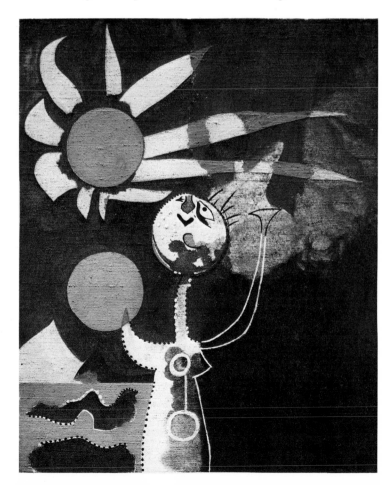

67 *Woman in front of the sun* 1938

through painting the spiritual path of the mystics of all periods.'
Far-reaching implications are born from the lightness of touch
which makes his work both a simple delight and a profound
experience. Woman and bird, substance and void, the obvious
and the inexpressible, are brought within our experience.

Behind the cheerful, innocent, even tranquil look in his face,
Miró has never been immune to attacks of violent anguish and
depression. He has, however, always been able to balance the
threats of imminent disaster by equally potent forces. It is the
ability to live with these tensions with comparative equanimity
that gives his presence among others a unique quality and a
sense of controlled power. He has occasionally expressed this
precarious condition in self-portraits, which, unlike the early
13 representational work of 1919, that faithful likeness of his early
naïveté, are metaphoric confessions of his inner life.

The later self-portraits, of which, apart from a few drawings,
there are only three, began with an important work on which
Miró bestowed a great deal of intimate thought. When he
returned to Paris from Spain at the outbreak of the Civil War
in 1936, he had again veered towards a degree of representation.
60 We find this in the tragic realism of the *Still-life with an old shoe*
(1937) and also in drawings from the nude, among which
Woman going upstairs (1937) is a powerful example of his
capacity to distort the female form with a cruel and violent
humour; beside her we find once more, lightly sketched, a
ladder, the symbol of escape.

68 Having again started to draw from life, he began a self-
portrait as a pencil drawing from his image in a mirror. He
worked on this for several weeks with the intention of turning
it into a finished painting. Beyond a few touches of colour, it
never arrived at this final stage; the result, however, was
already a magnificent work which could not be more complete.
Every detail gives evidence of his meticulous craftsmanship, of
his introspective character, of the vision of an inner eye for
which the horizon is the universe of his imagination, and of
the depths of his disquietude. It is, to quote Dupin, 'a visionary

portrait of a visionary painter'. The head appears to be enveloped in flames that do not consume it but emanate from it, and the eyes burn with an inner fire, like stars. He seems to exist in an atmosphere illuminated by suns, stars and comets, incandescent and explosive, but firmly holding his place in spite of their all-consuming power. Despite the lack of colour, this portrait literally achieves his desire that 'a picture should be like sparks. It should dazzle.'[5]

During 1938, Miró painted another image of himself in very *69* different terms. On a black ground he placed two large flaming stars surrounded by other stars and cryptic symbols, thus reducing the former introspective vision of himself to the single feature characteristic of the clairvoyant, the eyes.

More than twenty years later, in 1960, he again took up the same theme. After installing himself in his new studio in Majorca, he unpacked a large number of pre-war paintings and found himself in contemplation of the past. He had an exact copy in black and white made of the first self-portrait·of 1937, with the intention of working on it with the detailed precision of a Mantegna, but as he examined it again his original idea evaporated; the obsessional character of his earlier work provoked a violent reaction in which his ironic sense of humour became decisive. In mockery of his former lyrical intentions he painted over the copy, with a heavy black line, a child's *70* version of a head with three hairs sprouting from it, rising from a rudimentary body and neck. The only feature which is emphasized rather than overridden by this bold graffito is again the eyes, which are accentuated by circles that give them a ghoulish emphasis. The result is grotesque and disquieting. It is at least a convincing sign that modesty and continual self-questioning remain more characteristic of him than vanity. The treatment he gave to his former masterpiece was in fact similar to that which he has applied on other occasions to colour reproductions of appalling banality: he transformed it, with complete freedom and innocent delight, into an entirely new work.

War and isolation

THE CONSTELLATIONS

When the Second World War broke out, finding himself exiled from Spain, Miró left Paris and took a cottage, Le Clos des Sansonnets, in a very poetic spot near Varengeville-sur-Mer in Normandy, close to the house Braque had built for himself some years before. They were old friends and continued to enjoy each other's company. Here a period of detached equilibrium began, in spite of increasingly sinister events.

Miró had with him an album which he had chosen because of the unusually beautiful quality of its paper. 'Materials', he wrote to me recently, 'always excite me and give me points of departure of great richness.' He began, however, by painting several canvases influenced by the open landscape and birds in flight over the plain. In the same letter he explained how this led to his use of the album and the series of *Constellations* which forms one of the most brilliant episodes of his career.

'After my work [on oil-paintings] I dipped my brushes in petrol and wiped them on the white sheets of paper from the album, with no preconceived ideas. The blotchy surface put me in a good mood and provoked the birth of forms, human figures, animals, stars, the sky, and the moon and the sun. I drew all this in charcoal with great vigour. Once I had managed to obtain a plastic equilibrium and bring order among all these elements, I began to paint in gouache, with the minute detail of a craftsman and a primitive; this demanded a great deal of time. . . .

'We had to leave Varengeville in haste. In this region which had remained calm the Germans opened up pitiless bombard-ments. With the Allied armies completely defeated and con-tinuous bombardments we took the train for Paris. Pilar took Dolores, who was then a little girl, by the hand and I carried

71 *Flight of a bird over a plain IV* 1939

with me under my arm the portfolio containing those *Constellations* that were finished and the remainder of the sheets which were to serve for the completed series.

'We left Paris for Barcelona eight days before the entry of the Germans. We left there at once as a measure of prudence, and went to Palma where I could live peacefully, ignored by everyone and seeing nobody.'

After this journey, in the catastrophic summer of 1940, in which the only possessions he could save were the *Constellations*, it was nearly three months before he was able to find sufficient tranquillity to take up the theme again with the 'rigorous severity' it demanded.

'At this time', Miró continues, 'I was very depressed. I believed in an inevitable victory for Nazism, and that all that we love and that gives us our reason for living was sunk for

ever in the abyss. I believed that in this defeat there was no further hope for us, and had the idea of expressing this mood and this anguish by drawing signs and forms of which I had to be delivered on the sand so that the waves could carry them away instantly, or by making shapes and arabesques projected into the air as cigarette smoke which would go up and caress the stars, fleeing from the stink and decay of a world built by Hitler and his friends.'

It must be very rare that a series of paintings that contain such coherence and lyricism should be completed in the midst of such catastrophic events affecting both the native country of the artist and the country he has adopted as a refuge. It is a sign of the fortitude and equanimity of which Miró is capable that his work continued unchanged in its quality and its impact. When by good fortune Miró was able to send the complete series to New York in 1944, it was greeted as the first artistic message to arrive from Europe since the fall of France. In his preface to the exhibition given them by Pierre Matisse, André Breton referred to the gravity of the situation: 'No, the condition of art (of great adventure and discovery) has never been so precarious as in Europe during the summer of 1940, when its days appeared to be numbered.'[1]

In the *Constellations* Miró showed once more his ability to revert to working on a small scale with minute detail soon after having produced paintings of monumental size. As their title suggests, they form a microcosm of life and movement in space, interpreted by Miró with great sensibility. Our perception of familiar events, and that of the immeasurable arena of day and night that we inhabit, are blended together. There is a unity of style throughout the series which recalls the great compositions of 1933, but the scale is greatly reduced, and titles (lacking in the 1933 paintings) are inscribed on the back of each. Starting with backgrounds prepared with washes of muted colour in the way Miró has described, they become populated with his emblems, stars, circles, spirals, squares and triangles, drawn with precision and illuminated with brilliant

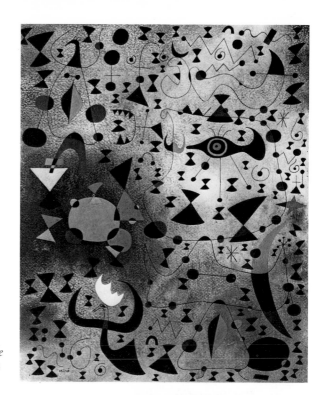

72 *Woman beside a lake whose surface has been made iridescent by a passing swan* 1941

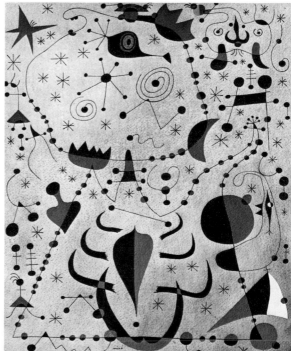

73 *Pink twilight caresses the genitals of women and birds* 1941

primary colours wherever the organic or geometric shapes intersect. Their poetic language is crystallized in titles such as *Woman beside a lake whose surface has been made iridescent by a passing swan,* or *Pink twilight caresses the genitals of women and birds,* or, more simply, *Women encircled by the flight of a bird.*

But the charm of the titles and the enchantment of the colour are balanced by angry faces that can be detected fiercely showing their teeth; also there is a restrained rigour in the drawing of certain recognizable shapes such as eyes, stars, the crescent moon, and a bold formal sign which Miró uses to designate the vulva, 'a Freudian heraldry of the Unconscious'.[2] Indeed, we find Miró here in his most seductive mood, using

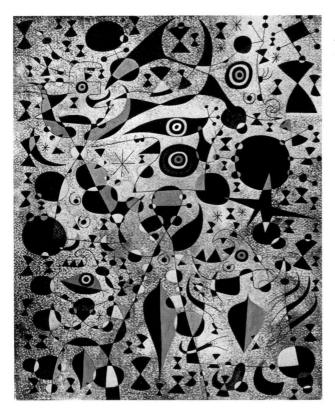

74 *Women encircled by the flight of a bird* 1941

75 *The nightingale's song* ▶
at midnight and
morning rain 1940

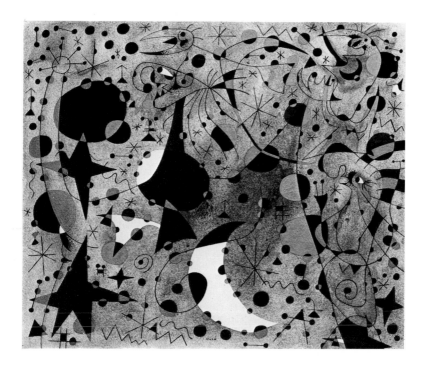

the full range of his talent. It is as though he had decided to condense all that he loves most, women, the night, stars, birds, dewdrops at dawn, into these small paintings, while emphasizing the precarious, illusory nature of our existence. Nostalgic themes such as *The nightingale's song at midnight and morning rain* 75 are troubled by the appearance of grotesque masks that reveal Miró's underlying anxieties. He presents us with a world that is vast and richly furnished with good and evil. 'He allows us to penetrate into the cosmic order', writes Breton, 'with all that is involved in going beyond our condition.'[3]

In subtle ways, Miró alludes to his desire to evade the horrors that menace him. *The Ladder of Escape* is the title of an early 78 *Constellation*, just as on 14 October 1940 he wrote on the back of another *The 13th, the ladder brushed against the firmament.* Another is named *The Migrating Bird*, and the last of the series, which

began with *Sunrise*, is *The Passage of the Divine Bird*. Perhaps the most expressive title, in circumstances from which deliverance seemed so improbable, is *People in the night guided by the phosphorescent tracks of snails*. Such hopes of salvation, discovered in the intimacy of the night, could still be a comfort, but the most ancient and infallible guide is known by Miró to be found for ever in the constellations themselves.

Situated in time between the *peintures sauvages* and the even more violent *Barcelona Suite* of fifty lithographs made in 1944, the *Constellations* have a measure of serenity which did not return to Miró's work until after the war. For this reason the series claims close attention; its poetic effect is greatly enhanced by the titles, and by the prose poems of André Breton which accompany each gouache in the facsimile edition.

76 *People in the night guided by the phosphorescent tracks of snails* 1940

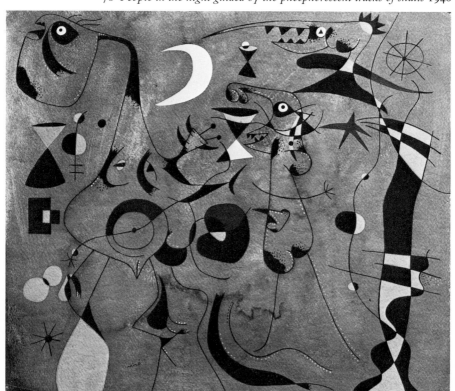

Miró's unexpected return to Spain after four years in France gave him the opportunity to rediscover, with fresh enthusiasm, the landscape and the architecture of Majorca. In Catalonia as a whole, the Gothic style developed local characteristics which give it unique distinction in its proportions and its rigorous control of ornament. The cathedral of Palma is a noble example of this style, both in the warm colour of its masonry seen from across the harbour and in the splendid proportions of its nave. Such things have long been important to Miró, and lie deep in the instincts which govern his work.

During this tragic period when he lived unobtrusively in Palma, he found satisfaction also in listening undisturbed to music in the cathedral. As usual Miró reacted in a very unconventional way, and to trace the direct influence of this music on his work would be impossible, although there is a painting of 11 May 1945 entitled *Woman listening to music*, and another of the same year, *Dancer listening to the organ in a Gothic cathedral.* 79 This latter might at least be expected to provide an easy clue. But its main feature is the flourish with which the line of a black arabesque dances across the centre of the composition; and, although the line terminates in a simple cross (a sign which for Miró does not necessarily refer to Christianity), nothing else refers to religion in any conventional way. The dancer is, however, flanked on both sides by grotesque figures, one obviously female. They have expressions of dumb piety or vicious nagging, while in the vault above floats a third figure with a large open all-seeing eye. The painting is as frankly pagan as any of Miró's Walpurgis Night fantasies. The relationship to music must lie elsewhere than in Christian ceremony. It is more probably to be found in the circular shapes that, overlapping each other, retreat into the darkness like echoes, and in the vibration in the black line above them. In these signs we can feel a relationship between sound, space and colour such as Miró has established even more forcefully in the

107

recent painting *Silence* (1968). That this extra-pictural relationship is present is undeniable, but even so it does not constitute the main appeal of the picture, which is an immediate delight in colour and the movement that is implied by static visual means.

In 1942, Miró returned to his home in Barcelona, where, at last, the political situation had calmed down a little. His painting was limited by a shortage of materials and also by a desire to purge his style of the minute detail that had preoccupied him throughout the *Constellations*. Once more he turned towards new methods of expression. It was in 1944 that he began, with his friend Llorens Artigas, his first experiments in ceramics; he also became deeply involved in executing a series of fifty lithographs which have become known as the *Barcelona Suite*.

Miró has described how, on leaving Palma where he had worked with great precision and concentration on small, detailed paintings, he felt the need to liberate himself. 'Now I worked with the least possible control,' he told James Johnson Sweeney, 'at any rate in the first place, the drawing.'[4] Lithography in black and white gave him the outlet he needed to express with unchecked eloquence the violent emotions that had been subjected to severe discipline after the first outburst in the *peintures sauvages* and the great paintings of 1938–9. The *Suite* discloses the same anger which had been provoked by the continuous deterioration of the international situation before the war, but in its directness it is even more disturbing. That there should be a long period of gestation in Miró's ideas is not surprising. It is indeed characteristic of the way in which he allows his ideas to develop subconsciously and reveal themselves with spontaneity.

The rapid technique of lithographic drawing suited Miró's mood. We find in the *Suite*, to quote Sam Hunter, that 'a ferocity of expression is here matched by superb control of composition and an astonishing richness of invention.... If anything, there has been a gain in psychological resonance and in the power to arouse disquieting emotion. Characterization

and plastic expression register simultaneously, fulfilling Miró's express aim of reaching the spectator with "an immediate blow between the eyes before a second thought can interpose".'[5]

The absence of colour allows Miró to concentrate on the eloquence of his line, and on his power to use black in all its shades to supply texture and dramatic effects, but it is in the unbridled freedom with which he uses signs of his own invention to describe the monstrous activities of men and women that these lithographs excel. Nor does he allow himself to lapse into tortured expressionism. His vocabulary of signs transposes the effect of despair to one of angry humour. Grinning teeth and horn-like mustachios introduce a sense of comedy and childish fantasy. The monsters delight us by their absurdity, and the 'black humour' of the nightmare becomes a fascinating make-believe in which our most primitive emotions are exalted.

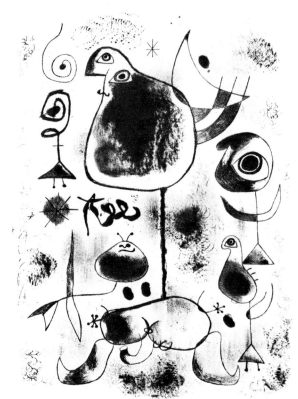

77 *Barcelona Suite IV* 1944

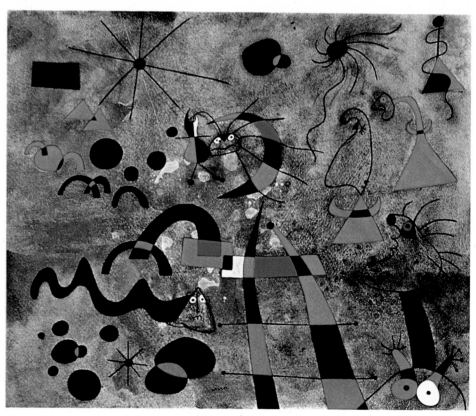

78 *The Ladder of Escape* 1940

The *Suite* is one of the most convincing examples of the power of Miró's signs. They are presented in a stark, compelling way. Eyes, which often occupy the greater part of a face, or appear in the void, catch our attention by their irresistible power of penetration; teeth, lining open jaws, pierce and wound; limbs, breasts, wings carry their parent bodies in space so that they float, fly, or dance without any contact with the ground beneath them, their sexual organs candidly exposed. Never before had Miró been able to expose so spontaneously the depths of his agony.

110

79 *Dancer listening to the organ in a Gothic cathedral* 1945

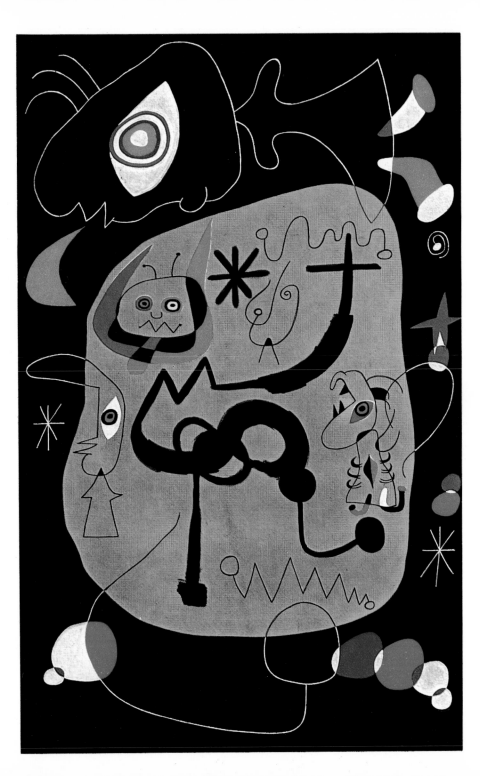

New horizons

In 1944 the death of Miró's mother resulted in the sale of the apartment in the Pasaje del Crédito, which Miró had been using as a studio since his return from Palma. Another event that heralded important future developments was the dispatch of the *Constellations* to New York through the help of a South American diplomat, and their exhibition the following year at the Pierre Matisse Gallery.

For four years Miró had not painted in oil on canvas, but his return to this technique took place with great ease and profusion. Continuing to prepare the ground with a variety of materials, he also began to use unconventional shapes for his canvases. Long narrow strips were used horizontally or vertically; along them signs could be read as a phrase from a new visual language. Other canvases were irregular in shape, or had frayed edges that dissolved into the space round them. The signs also developed a tendency to become more calligraphic and ambiguous, with resemblances to both hieroglyphic and alphabetical scripts.

At last, in 1947, the period of isolation came to an end. Miró was able to make a first visit of eight months to New York, where his work had received wide recognition since the retrospective exhibition of 1941 at the Museum of Modern Art. There he met Yves Tanguy and Marcel Duchamp, his surrealist friends, and Alexander Calder, whose drawings and mobile sculptures have always had an affinity with his own work. He also found in New York his compatriot José Luis Sert, the architect who was to build the studio in which he now works near Palma.

Hearing of his arrival, the directors of the Terrace Plaza (now Hilton) Hotel in Cincinnati, Ohio, asked Miró to paint

a ten by three metre mural in the hotel restaurant. This was a commission directly in line with his desire to express himself on a large scale in a place frequented by the public. He spent a large part of his time in New York working diligently on etchings at S. W. Hayter's Atelier 17, where he astonished his friends by the enthusiasm with which he entered into new experiments in technique. It was there that he produced the etchings for a book of poems by Tzara, *L'Antitête*.

Being very much alive to his surroundings whenever he travels, Miró reacted deeply to the atmosphere he found in the United States. The vitality and youth of its life, the vast scale of its architecture and landscape, the lights of its cities and the blatancy of its advertising, were the first factors that struck him, and brought exhilaration; but, even so, no obvious sign of these influences showed in his work.

Leaving America in 1948, Miró returned to Paris after an absence of eight years. Here again he received a warm welcome from his old friends. The year before, he had contributed some important works to a surrealist exhibition organized by Breton and Duchamp at the Galerie Maeght, and his friends the poets – Paul Eluard, Raymond Queneau, Georges Limbour, Maurice Raynal and others – expressed with eloquence their pleasure on seeing him back.

His visits abroad had provided Miró with a new stimulus. During 1949 and 1950 he produced a great quantity of paintings in two opposing styles, those on which he worked with concentration and perfection of detail – 'slow paintings', Dupin calls them – and others which were astonishing for the urgency of their invention – 'spontaneous paintings'. In both cases the initial preparation of the background took place in advance, and Miró has rarely shown greater science and sensibility in this practice.

In the 'slow paintings' the signs and the general composition were developed with painstaking application and an attention to detail such as he had given formerly to works like *The Farm* 17
and the *Constellations*. Returning to them again and again, he 71

113

80 *Women and birds in the moonlight* 1949

81 *People in the night* 1950

would correct every feature until an impression of absolute
finality was achieved. The forms and lines have great precision,
and the brilliant primary colours of his signs, in which white
and black also play an important role, produce an astonishing
liveliness and luminosity which may be seen in such works as
Women and birds in the moonlight, now belonging to the Tate *80, 81*
Gallery, or *People in the night*.

In this series, as in the compositions of 1933, Miró seldom
gave titles to the paintings. As Dupin explains: 'The subjects of
the pictures become effaced, they are no more than a pretext, or
the accompaniment that sustains the melody.'[1] The paintings
are a splendid example of complete accord between the signs

82 and the background, which is often enriched by the addition of textured surfaces built up or scraped down until there is a complete unity between the deep atmospheric recessions and the animation, in line and form, of the signs that appear to float in the foreground.

In the 'spontaneous paintings', which he was doing at the same period, Miró gave complete freedom to the ingenuity with which he is so well endowed. It was another proof of his ability to use methods widely opposed to each other with equal success. The 'spontaneous paintings' are surprising in the diversity of the materials used, and in the invention of new forms which add to the family of his signs. Backgrounds are often heavily textured, with wire and string incorporated in the composition. In many cases the signs seem to melt into vaporous mists in the background or combine with splashes of colour thrown at the canvas, a method which was to be taken up by other painters and labelled 'tachism' a few years later. The exquisite exactitude of outline, and the clear primary colours, of the 'slow paintings' are replaced by vigorous arabesques in which it is a delight to follow the line as it changes in emphasis and direction. To trace its course is in every case a dramatic experience; thus, some lines which have moments of bold swift movement, in which the physical action of the hand is evident, travel on to become blurred and absorbed into the background.

Again, Miró was usually not interested in giving titles to these paintings. The urgency which makes itself felt throughout puts them into the category of works which must be enjoyed for the freshness of their improvisation. Although their spontaneity makes it inevitable that some are more satisfying and significant than others, the whole series constitutes one of Miró's major achievements, which is enhanced by the contrast with the more deliberate, measured clarity of the 'slow paint-
83 ings'. An admirable example can be found in the 1950 picture, now in Eindhoven, in which Miró has used knotted cords breaking through a background of frenzied colour and varied

82 *The blaze of the sun wounds the lingering star* 1951

textures. In this tempestuous atmosphere float creatures drawn with the precision of those of the 'slow paintings'. Others, however, such as *Woman in front of the sun* (1949), are purely *84* spontaneous and enjoyable, like the movement of an unpre- meditated dance.

The rich variety that followed after the divergent trends of 1949–50 was due largely to the freedom of action that Miró was now able to combine with the detailed calculation which had been an essential condition of the 'slow paintings'. Titles adding their lyricism to the works again made their appearance, and the methods and materials used for the integration of signs into the mysterious depths of the background became even bolder and more surprising.

117

83 *Painting* 1950

84 *Woman in front of the sun* 1949

Opportunely, Miró was commissioned in 1953 to paint a very
87 large picture for the Solomon R. Guggenheim Museum in
New York. For the first time he worked on an immense virgin
canvas without preparation or previous studies, and in spite of
this change in his methods he achieved a combination of sponta-
neous freedom with an impressive display of powerful forms.
The ferocity of this painting recalls in a brutal manner the
monsters of the *peintures sauvages*, but the violence is now
contained in the manner in which the forms are painted rather
than in their individual expressions. The method used here is
the antithesis of the calculated precision of the signs and
figures of the 'slow paintings'. There is a complete disregard
for delicate refinements. Instead, there is a 'fecund clumsiness', a
direct and brutal assertion of the inner energy that the painter
has succeeded in liberating. Stains, accidental blotches of paint,
and crude hasty brushmarks contribute to the urgency of the
message that is being proclaimed. Even the portentous assurance
and overwhelming proportions of the central figures become
ambiguous and are absorbed into a splendid display of trans-
muted emotion. Against the confused vaporous colouring of
the background the massive red and blue form of the dominant
figure makes an impressive contrast.

The savage element is not absent in smaller paintings of this
89 period, such as *Woman struggling to reach the unattainable* (1954).
Here once more Miró has renounced all grace and lyrical
charm in favour of a more direct form of expression in which
the unembellished gesture is made to speak. There are other
paintings in which biomorphic signs tend to become obscured
and the movement and colour of more indeterminate graffiti
85 become increasingly eloquent. In the painting *Hope comes back
to us as the constellations flee*, the phantoms of symbols become
faintly entwined in a luminous primeval fluid. Three black
elliptical shapes punctuate the composition like large holes
pierced through to infinity or, indeed, like eclipsed suns
travelling over the surface of the painting. The ambiguities of
depth are accentuated by the reassuring imprint of hands

85 *Hope comes back to us as the constellations flee* 1954

86 *The heavens half open give us back our hope* 1954

scattered over the surface of the canvas, of which we should otherwise cease to be conscious. In another version of the same theme, *The heavens half open give us back our hope* (1954), depth and atmosphere are established by a fantastic choice of techniques applied with what appears to be unrestrained brutality. The blackness of the background has been fiercely worked by scratching, rubbing and the addition of textures in casein. Again handprints appear, now white against a fathomless darkness, as a reminder of the surface of the canvas.

86

87 *Painting* 1953

Miró has always had a desire to branch out from the high road of painting into other media, and to re-establish a connection with the public, independent of the conventional contacts through dealers and museums. Between 1954 and 1959 he devoted much of his energy to ceramics and to lithography and engraving.

In 1959 Miró again visited the United States at the time of a second retrospective of his work in New York, at the Museum

of Modern Art, and also in Los Angeles. International recognition of his genius had already begun when he was awarded the Grand Prize for Engraving at the Venice Biennale of 1954; and in America, where appreciation of his work was far in advance of Europe, he received the Grand International Prize of the Guggenheim Foundation from the hands of President Eisenhower.

Miró has often claimed that he prefers to work in discomfort. The bohemian squalor of the rue Blomet was overcome by whitewash and his systematic tidiness. The cramped quarters at Montroig and the Pasaje del Crédito, where he had literally to crawl under his canvases on his belly, never impeded the freshness of his inspiration nor the quality or quantity of his work. But a combination of circumstances, a house among olive trees on a hillside at Calamayor near Palma with a splendid view of what then was an unspoilt coast, his lifelong friendship with José Luis Sert, and a half-suppressed wish that Miró had expressed when he said in 1938 'I dream of a large studio'[2] – these factors persuaded Miró in 1956 to commission his friend to build for him a studio among the terraces and olive trees of Calamayor. This combination of Miró's needs and Sert's understanding produced excellent results. The siting, the appearance, external and internal, the lighting and the functional qualities were admirably conceived. But as might have been foreseen, Miró had difficulty in adapting himself to an atmosphere of such perfection, and more than two years passed before he was able to establish himself there at all. It was only in 1959 that he was again able to paint, and a new period of activity began.

A few years later, in order to satisfy his need for a close contact with the peasant life of the past, he bought a neighbouring farmhouse of splendid eighteenth-century proportions built of the local golden-coloured stone. In the whitewashed emptiness of its lofty rooms he is able to withdraw, meditate and wander among the stacks of canvases and found-objects in all stages of achievement and metamorphosis.

The completion of the new studio brought an important consequence. Since his flight from Paris in 1940 a large quantity of half-finished canvases and objects had remained in store. It was now possible for Miró to see them again, and with great concentration he sorted them out. Some were rejected, but others he judged could receive further attention although the idea of completing a work in the same spirit as that in which it had been begun some thirty years before was inconceivable. Although Miró often works on a picture over a very long period, he never retouches. When he returns to a previous work he uses it in an impersonal way as the point of departure for fresh inspiration. A painting which illustrated his mood on recovering his pre-war work is the *Self-portrait* begun in 1937, the treatment of which I have described in another chapter (see p. 97). In *Swallow dazzled by the flash of the red pupil* (1925–60), it is difficult to find traces of the original, but the finished painting without doubt owes its richness to its past history and offers a proof of the continuity in Miró's work and his power of renewal.

68, 70

88

88 *Swallow dazzled by the flash of the red pupil* 1925–60

89 *Woman struggling to reach the unattainable* 1954

The new studios opened for Miró the possibility of expansion, and not only in a physical sense. We have already seen how he often chooses to work in opposite modes and vary the media of his expression constantly. The additional space of the studios gave scope to the sense of orderly development and continuity which is a fundamental basis of Miró's work, just as the soil on which he walks is the springboard for the flights of his imagination. There was thenceforth always to be more than one trend to follow in his work, and at times they would even appear to be diametrically opposed. The new studio, a few yards only from his house at Calamayor, has become the centre of painting, still the focus of all his activities; and, with this and the more primitive house higher up the hill, he is furnished with all the space and the means he needs for painting and the germination of ideas which are later worked out in other forms elsewhere – at the foundry in Barcelona, the kilns of Gallifa and the workshops and presses in Paris and Saint-Paul de Vence.

After his return to painting in 1959, simultaneously with the execution with Artigas of a ceramic mural for Harvard University and continued production of graphic works, Miró found himself working out new paths, characteristically varied in direction, in his studio at Calamayor. A series of small canvases identical in size, known as the *Fonds blancs* ('white grounds'), revealed a new tendency. In the first group, nebulous shapes move in an atmosphere of impenetrable mist. In the second, 91 over the same deep white cloud, disconnected lines have been rapidly scribbled on the surface with a disregard that could be called 'anti-drawing', giving an effect of depth similar to the handprints of the paintings of 1954. A third group has an even 92 greater degree of abstraction. The white ground is marked by bold splashes of black paint thrown at its surface so that the gesture of throwing becomes imprinted and frozen. At the 90 same time Miró was making a series in which, with a bold precision characteristic of his fluent calligraphy, he painted signs using a thick brush full of black paint on pieces of coarse hessian cut from old sacks. The sacking was otherwise left bare, and

commercial lettering stencilled on the sack became part of the composition. The signs, developed from his symbols of birds and women, are recognizable by their movement, but the chief delight of these small works lies in the primary colours sparingly used to solidify certain shapes, the nebulous spots of colour in the background, and the conviction of the line that delineates the forms and dances round them.

90 *Woman and Bird II/X* 1960

93 *Painting on* ▶
torn cardboard 1960

94 *The Red Disc* 1960 ▶

91 *Painting I/V* 1960

92 *Painting II/V* 1960

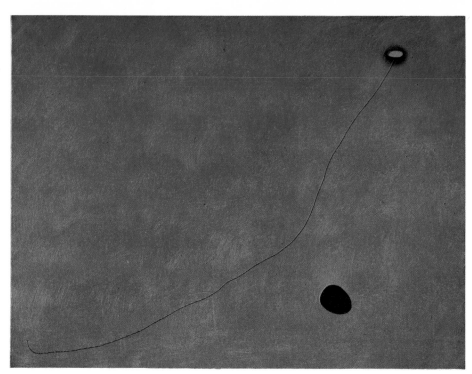

96　*Words of the poet* 1968

95　*Blue III* 1961

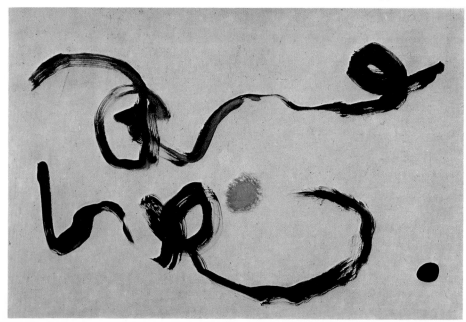

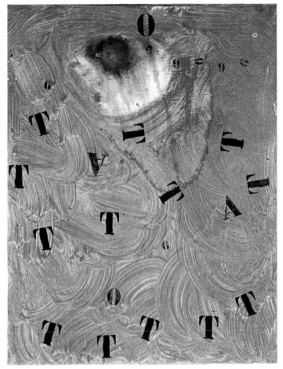

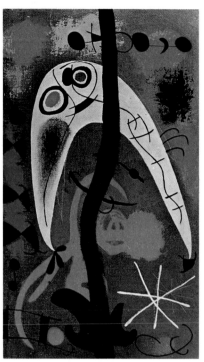

97 *Letters and numbers attracted by a spark III* 1968

98 *Woman and birds at night* 1968

99 *Dance of people and birds against a blue sky* 1968

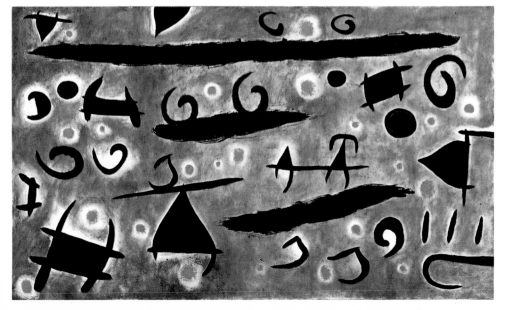

Another very different mood accounts for a large number of
92, 93 paintings on thick sheets of cardboard, a material which
attracted Miró by its banality, and on which he exerted every
means, such as tearing off corners, gouging out patches and
holes, soaking it to make it warp, and adding rich textures to
bring its sluggish surface to life. Again, as with the 'spontaneous
paintings', the results vary in quality. His triumphs are those
in which there is a metamorphosis. The unattractive disintegra-
ting material itself becomes an imposing mass, the vehicle
which carries the bold and vital indications of life given by the
colour and signs bestowed on it by Miró.

Just as Miró exalted the meanest of materials in paintings on
cardboard or other pieces of rubbish, such as fragments of
fibro-cement, that attracted him by the banality of their shape,
93 so at other times he used the blots made at random on a canvas,
interpreting them with a minimum of signs, and with colour
applied with the same haphazard appearance. These touches
owe their significance to the mysterious precision with which
they have been placed, and the tact with which they enhance
rather than alter the original stain. In such paintings, 'the blot
itself possesses a significant power in Miró's creation', writes
Dupin. 'It illuminates slowly the genesis of forms and figures
beginning from the raw material, supreme and blind, that
contains the vital energy without which the effort is no more
than another stage towards the inevitable return to the material
itself.'[3]

Experiments such as the *Fonds blancs* were to lead to new
developments in Miró's conquest of space, a preoccupation
that we have noticed in his work as early as the blue 'dream
paintings' of 1925. It was now to find its expression on a much
95 greater scale in three paintings of 1961, *Blue I, II, III*.

Miró was now to forgo all the enchantments of his signs and
symbols and concentrate only on the liberation of the spirit in
space. These three great canvases of limitless blue mist owe
their sensation of depth to black spots and bars of brilliant red
which hover in the foreground, close to our eyes. Also, in two

of the paintings a tenuous black line like a kite-string crosses the canvas and penetrates deep into outer space.

In 1962 Miró pursued even further his intention of creating a sense of space with the simplest possible means in three large canvases entitled *Mural paintings for a temple: Yellow, Green, Red*. Denying even the nebulous play of colour on the canvas, and limiting all figuration to a few black circles and tenuous lines, he has created an environment of pure colour for our contemplation, with rare focal points which can provide anchors for a hypnotic meditation. His purpose was not decoration but rather to offer a means of escape into the infinite, for which the ladder in former paintings had been a symbol.

The deliberate elimination of signs and of all traces of representation in these canvases would appear to bring Miró dangerously near to pure abstraction, which in the past he had violently rejected as a means of expression. As we shall see, however, by an even more stringent application of the same process, he has recently produced a triptych of great purity and significance, the *Mural paintings for a hermit's cell* of 1968.

It is evident from the great retrospective exhibition held in 1968 at the Fondation Maeght and later in Barcelona, and in 1969 in Munich, that the quantity and variety of Miró's output in the last decade has been prodigious. But beyond this remarkable achievement is the progress towards new powers that Miró is able to incorporate into whichever mode of expression he is using. In the great exhibition in Barcelona, the works dated 1968 amounted to over sixty paintings, the majority being of large dimensions, twenty-eight graphic works, and over thirty sculptures, mostly in bronze.

It might be thought that such an astonishing output could lead to repetition and weakness due to haste, but the mastery Miró has attained in so many different forms of expression and the richness of his imagination save him from any such reproach. In the 1968 paintings he has developed new methods. There are those in which the gesture of his hand and the dramatic sensitivity of line are supreme. Vigorous examples of this are

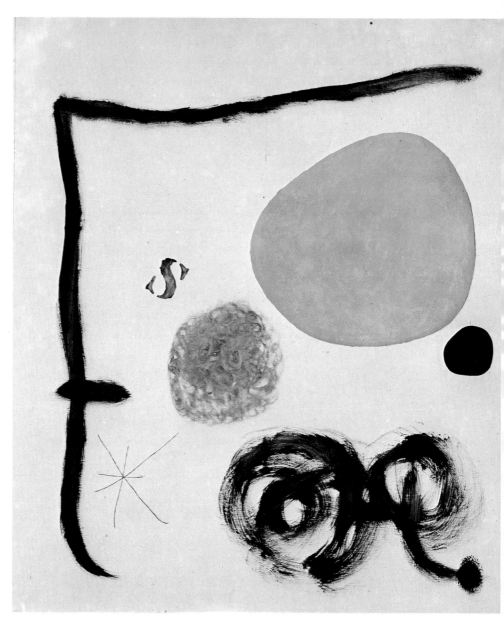

100 *Poem III* 1968

134

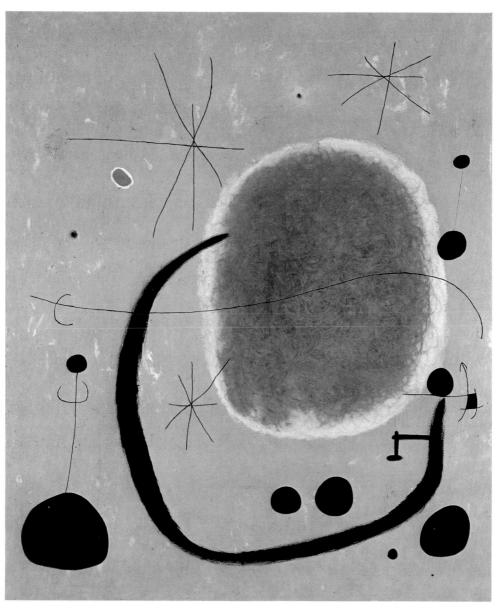

101 *The Gold of the Azure* 1967

96, 100 *Words of the poet* and *Poem III*. In both paintings the effect relies above all on the flourish of a line punctuated with spots of bright colour which, as we follow it, speaks a dramatic language with continuous eloquence. The same applies to the family of signs and arabesques which covers the canvas in

99 *Dance of people and birds against a blue sky*; an equally astonishing

97 flight of stencilled letters and numbers appears in *Letters and numbers attracted by a spark*. The ground of liquid red on which they cluster is broken into by the explosion of green fire. Unlike early paintings in which the letters spelt out a word or even his own name, here they are depersonalized, abstracted from an exact interpretation so as to be read as a mysterious language which he helps us to invent for ourselves.

101 The painting of 1967, *The Gold of the Azure*, is a splendid example of Miró's ability to combine new forms with the exquisite calligraphy of signs and stars. The large transparent blueness of an isolated elliptical mass gives the sensation that the immensity of the heavens can be rolled up into one ball, floating in a golden atmosphere which is populated by indefinable creatures, and by the galaxies of outer space, red and green in the immeasurable distance.

There are other paintings in which Miró's attachment to the night and the nocturnal presences of women and birds is evident; but Miró does not see the night as darkness. For him, paradoxically, the happenings of the night are conceived in a brilliant display of colour. The small painting *Woman and*

98 *birds at night* (1968) is rich in primary colours, which create the background; the tall serpent-like form barring the centre of the picture, which is woman, is black, as are the bird-like signs that fly round her. Miró, as usual, remains ambiguous in his use of signs, and the large white crescent that dominates the composition can be interpreted either as the moon sailing through the sky or as a bird in flight. In this painting we find a deliberate return to the symbolism of earlier paintings; the signs, while they have gained a new lyricism, have become more integrated into the composition. Another triumphant

136

102 Flight of a bird encircling the woman with three hairs during a moonlight night 1968

tribute to the night is found in *Flight of a bird encircling the woman* 102
with three hairs during a moonlight night (1968). Here the arrange-
ment of the composition is amazingly simple. Only three
primary colours are used with black and white. With the
ingenious contrast of the white star and circling birds, and the
apparent distance created by the curve of the green crescent
moon showing light against a black sky, a reversal takes place
below as the black flows into the border of the red circle, and
the delicate tracery of stars and birds surrounding the sign of
the woman moves in silhouette against the golden moonlight.

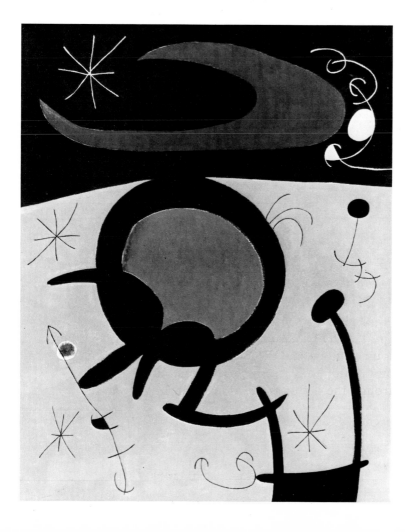

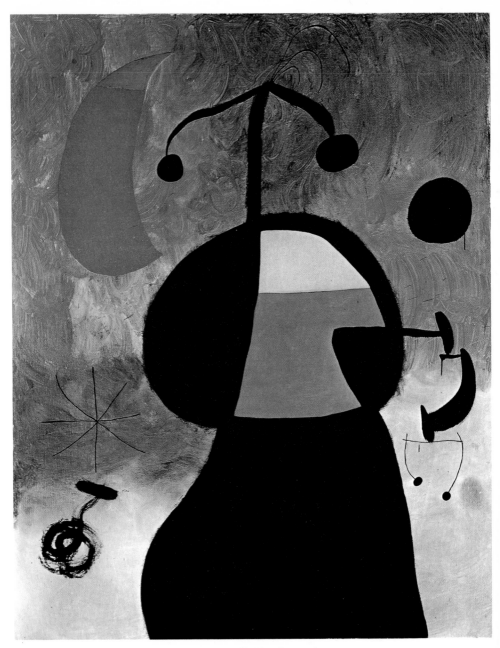

103 *Woman in front of the eclipse, her hair ruffled by the wind* 1967

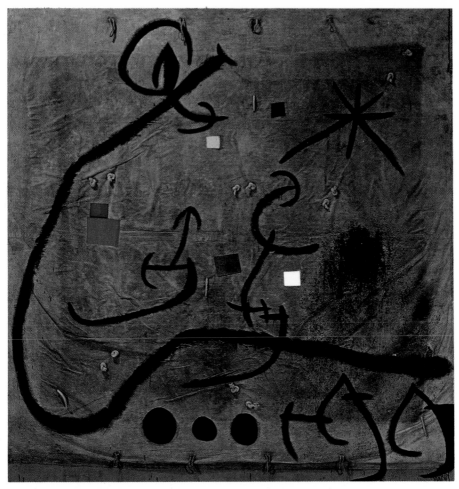

104 *Woman surrounded by a flight of birds in the night* 1968

An earlier painting, *Woman in front of the eclipse, her hair* *103*
ruffled by the wind (1967), reveals to us the strength of Miró's
style in recent years. It can be compared with the *Portraits* of *68, 69*
1938 in the economy of its means, but it also combines the
spontaneity of recent experiments in texture, which appear in
the background, with a determined and yet sensitive structure,

seen in the figure of the woman herself. There is an impressive sense of finality in the placing of the heavy black forms of the figure, contrasted with the careful drawing of the signs beside her and the sparse use of pure colours. In particular, the composition depends on the placing of the patch of yellow in relation to the green, and the red crescent tipped with blue. Keenly sensitive to the role of each colour, Miró often uses yellow, as he does here, as the source of light in a picture, placing it last and giving it a role of essential importance. The authority that emanates from this painting is clearly the outcome of long experience and a struggle to situate the maximum of significance in a picture without lessening in any way the spontaneity of action which is necessary if the springs of the imagination are to flow freely.

Two important paintings of 1968 show once more the strength of Miró's desire to experiment with untried materials. In both cases he has used large pieces of crumpled sailcloth with their cords still dangling from them and their holes and stains 104 still apparent. *Woman surrounded by a flight of birds in the night* (1968) is a piece of tarpaulin measuring more than three metres square. Miró has discovered in it a background full of associations. He decorates it with a bold arabesque of bird signs, surrounding the serpent-like form of woman that moves across the bottom of the canvas. Her form is like the outline of hills, and rears up into the centre of the composition as it approaches the rays of a large black star. A movement following the creases of the canvas might have become facile, but he arrests it by placing with deliberation small squares of brilliant colour stuck to the canvas, and adding knots of cord in pairs like eyes in the night. There is again great sensitivity and skill in the way Miró has used the crumpled texture of the background. The vast scale increases the ambiguity of the effect; the painting can appear like a wall of elephant hide, or open up and envelop us in a deep limitless space. It is a further example of his masterly skill in the handling of uncouth materials and his mysterious power of creating depth.

Sculpture and other media

Many of Miró's sculptures, as I have said before, evolved from
the early surrealist objects which were made of unexpected
combinations of elements. This process often involved the use
of random discoveries among the insignificant objects, natural
or artificial, that litter the world around us, waiting to be given
a new life through the metamorphosis that Miró is able to
bring about. He has made sculptures built up of broken pots, *105–7*
old roots, limbs from celluloid dolls, sticks, electric bells and
feathers, which come to life as projects for monuments to be
constructed later in concrete, bronze or a mixture of materials.
In spite of the meanness of the original material, a hieratic
presence emerges; the transformation that has taken place
brings a sense of elation that the spirit can be restored into such
a heterogeneous collection of despicable trash. This process has
been exploited by innumerable artists in recent years; but Miró
has the rare ability to create each time a new conception which
is entirely convincing in its own personality.

Miró admires greatly the traditional Catalan figures, model-
led in clay and usually painted, which are still made in remote
parts of Majorca and which have a resemblance to the archaic
sculpture of all primitive people. The simplicity of their forms,
in which can be felt the imprint of the fingers that modelled
them, has influenced him in many small works made in clay
or plaster. Here also, Miró's symbols find a three-dimensional
interpretation, becoming tangible and giving delight through
the textures of their surfaces. The internal life which is enclosed
mysteriously in their form, the signs incised on the exterior,
as well as their colour, add significantly to their meaning.

Miró, as a skilled craftsman, has many ways of developing
his ideas. Small constructed sculptures can become monuments,

and the original ephemeral materials can be cast in concrete, marble or bronze.

In the great flow of creative energy during 1968 that produced such riches in painting and other media, there came into being a group of bronzes in which Miró found the means of giving expression to his artistic ingenuity.

111 Again, it was often the meanness of an object or a material that attracted him and gave him a starting-point. In a basket, of the kind traditionally used in Mediterranean countries by builders, he sees a head. The handles become its ears, and drooping eyes and a snout are made from parts of a celluloid doll. This assemblage is then mounted on a body which has the

105 *Man and woman* 1931

106 *Poetic object* 1936
The Museum of Modern Art, New York

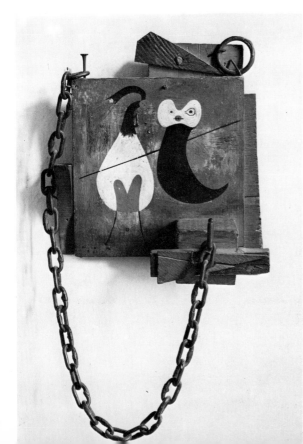

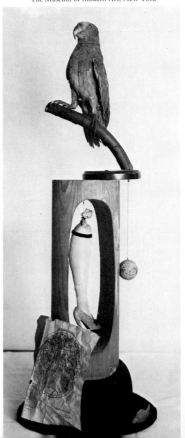

appearance of being wrapped in a toga, in the lower part of which a limb, again detached from a doll, protrudes in an ambiguous gesture of greeting. This strange mixture of objects finds a new unity by being cast into bronze. Under his instruction, José Parellada, a young craftsman in Barcelona, cast more than a dozen figures by Miró in 1968 and gave them a patina which is admirably suited to the process of unifying the heterogeneous ingredients.

Another of these sculptures is cast from three elements. The two lower ones are irregular oval patches of clay set vertically, each bearing the imprint of a foot, and both supporting a square tile, on which has been incised a face with large round eyes and *113*

107 *Object of sunset 1938*

108 *Ceramic figure 1956*

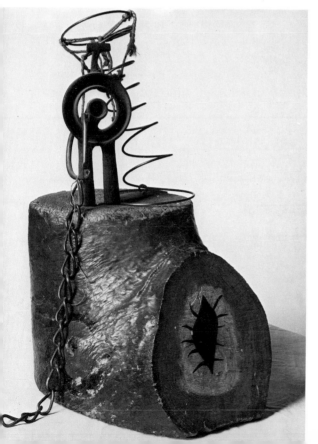

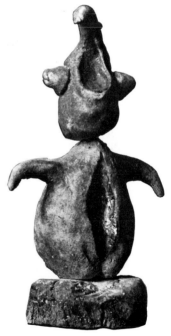

a highly equivocal expression. There is a choice as to how the figure is to be interpreted. The feet could equally well be hands, or perhaps a cloak enclosing the empty central area which becomes the body of a square-faced gentleman.

112 In another, taller figure, Miró relies more exclusively on the rough texture he has given to the original clay. The only extraneous materials used are stones embedded to emphasize certain points. The overall shape of the figure contains the ambiguity of the symbols that appear in the paintings. From the pear-shaped body in which two vertical rifts have been opened, suggesting the holes in a violin, rises a long neck with arms attached to it like the barbs of an arrow, giving the figure a curiously hermaphroditic appearance.

It is perhaps when at work on ceramics that Miró enjoys most completely the full scope of his genius. There is no facet in the wide range of his talents that does not come into play, and in addition he is assisted by an old friend, Joseph Llorens Artigas, who has shared his ambitions and disappointments ever since they met in Barcelona at the Sant Lluch circle in 1915, and who has since become an expert in the art of ceramics.

Artigas has adapted himself willingly to Miró's astonishing career, with a desire to make it possible for the artist's most unconventional ambitions to be realized. He has installed his kilns close to his house in the isolated village of Gallifa, on a mountainside near Barcelona. With a knowledge of Chinese and Japanese techniques, and the sensitivity of a man who has mastered all the refinements of his craft, Artigas has made it possible for artist and craftsman to supplement each other's qualities as they work together. He refuses to install gas or electricity, and uses only the wood from the forests to get the high temperatures he needs in his kilns.

108 Ceramics are for Miró an extension of both painting and sculpture, in which many of his discoveries in both arts can be combined. There is everything in this art to enchant him. It begins with the earth, the clay which can be modelled in the hands, pressed against an object or a surface so as to receive its

144

imprint, thrown on a wheel so that it has both an exterior and an empty space within; its surface can be embellished with colour, texture and signs. The next stage is more dramatic. Fire now takes all into its control, and artist and craftsman stand aside, imposing their will only in so far as they are able. Miró is undismayed: the firing may by some unaccountable freak produce a result which was unexpected, but he is prepared, as in his paintings, to find ways of taking advantage of such happenings. He and Artigas work with the elements, and the results bear the imprint of a profound understanding between themselves, and between man, earth and fire.

The literal fusion of sculpture and painting allows Miró to use the primary colours which are significant in his painting and to gain three-dimensional effects in which paint is no longer an illusory medium evoking depth on a flat surface but part of a solid object which can be touched and which can contain space as well as occupy it. The senses of sight and touch, which he has so often combined in the illusions created by his paintings and collages, here unite, and Miró exploits the possibilities offered with great skill. In figures such as *Person with a large head* *109* there are forms and surfaces which have clearly defined associations; the head in this case seems ancient and worn like a block of lava, whereas the body has the sharp roughness of a crudely woven garment. In other ceramic sculptures we feel the surprise brought about when a substance, such as clay that has been fired, is put together with other materials to form a unity. A presence such as this exists in *Monument to Maternity* (1962); *110* from its wooden body, which is flat and round like the cover of a barrel, rises a very long ceramic neck and head. In other hands, such sudden changes of material might strike us as merely incongruous, but with Miró's sensibility, and the sense of humour he shares with Artigas, they not only win acceptance but involve us in a mysterious metamorphosis. The bewildering success of these marriages of improbable materials is the result of Miró's ability to make use of anything that is at his disposal.

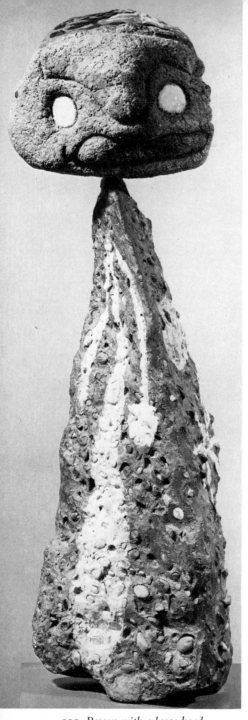

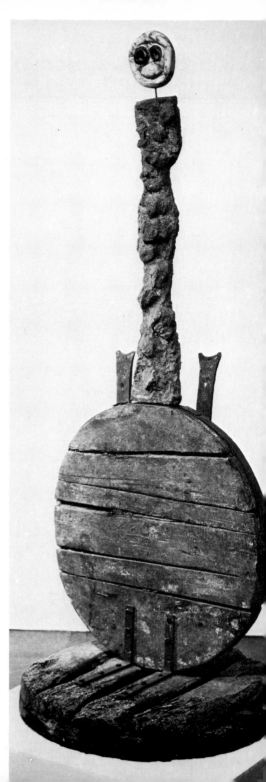

109 *Person with a large head*

110 *Monument to maternity* 1962

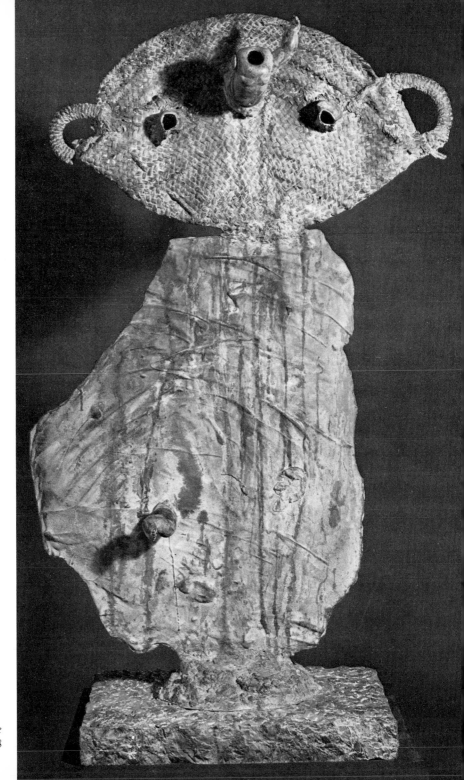

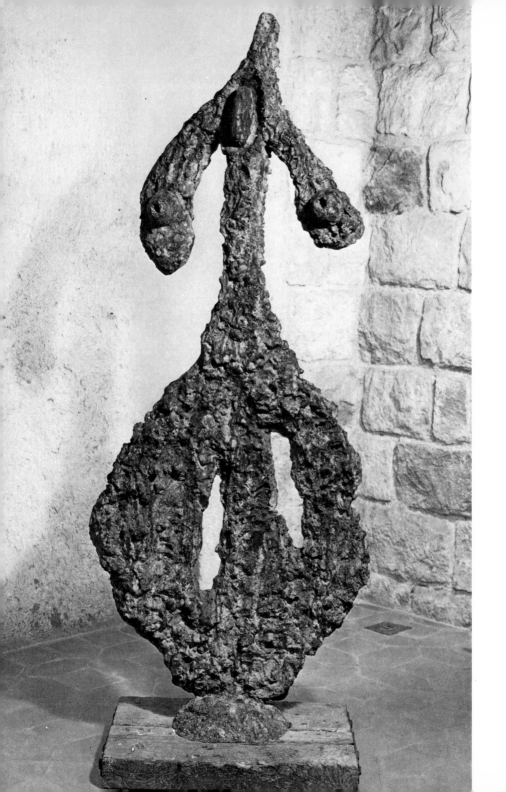

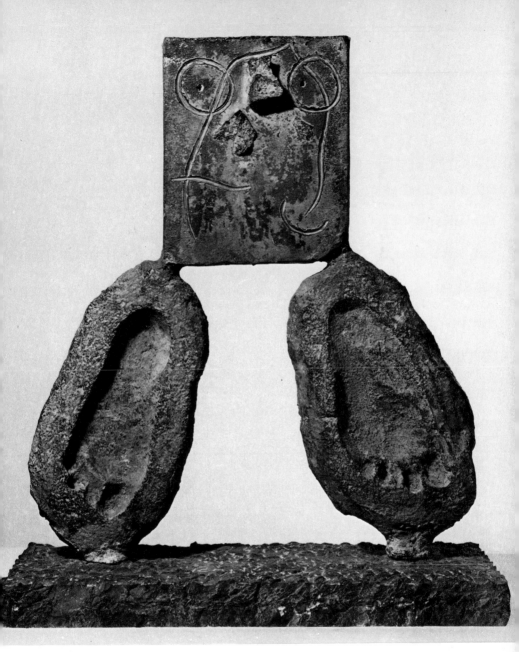

113 *Sculpture* 1968

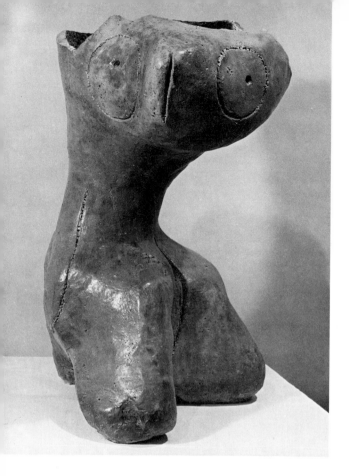

114 *Woman (green)* 1968

Whatever the medium he uses, there is always a close affinity in Miró's work to the natural forms around him. The powerful landscape of Catalonia has always been, he tells us, 'an essential element in my plastic and poetic conception'. He has often found the stimulus he needed for his ceramics in actually painting directly on the surface of rocks which form part of the mountain landscape. And when his colours, signs and surfaces have become fused into a ceramic he enjoys seeing them again in natural surroundings. They are at one with the landscape, a result which he knows would be impossible and ridiculous should he try to place a naturalistic painting against a mountain.

150

Co-operation with nature continues throughout. Miró does not make drawings in advance for his ceramics, and their variety of form is enormous: some are sculptures, others plates *114* and jars, others small precious objects, while others are made to take their place in architecture. When asked by Rosamond Bernier which of these many kinds he preferred, Miró replied: 'It is always the last, the one just out of the kiln, about which I feel most strongly. Some of the new ceramics are very big. I have been working with a sense of the monumental, thinking of their possible incorporation in architecture. This could be the way to enrich workers' dwellings and no longer treat those who live in them as insensitive robots.'[1]

In other ways, ceramic art can approach painting more closely. In several places Miró has created masterly designs for tiled walls, either isolated like those outside the Unesco building *116, 117* in Paris, or as part of the architecture like those at the universities of Harvard and St Gallen in Switzerland, where the design is a long, narrow frieze. We now await the new design of monumental proportions at the airport of Barcelona.

MONUMENTS

Physically Miró belongs to a Mediterranean race who are small in stature, but whose achievements are often monumental. His capacity to produce so vast a quantity of paintings, engravings, lithographs, ceramics and sculpture reminds us of his compatriot Picasso. Although Miró pays meticulous attention to detail in his work, he has always had a strong desire, and the ability, to express himself on a very large scale. The easel picture appears unsatisfactory to him for two reasons. It does not offer a physical sense of environmental space, nor can it be incorporated appropriately into architecture and public places. As early as 1938 he wrote: 'I want to try, in so far as possible, to go beyond easel painting, which in my opinion has too mean an aim, and get nearer in painting to the masses of whom I have never ceased to be aware.'[2]

Before the war, large-scale designs for the ballet, cartoons for tapestries and decorations for the children of his friend, the architect Paul Nelson, gave him the possibility of showing that the strength and simplicity of his style could be admirably adapted to monumental design.

61 One of the largest paintings was the great mural, *The Reaper*, commissioned for the Spanish Pavilion in the Paris International Exhibition of 1937; placed at the top of a flight of steps, it filled a whole wall. But owing to the misfortunes of war it disappeared mysteriously when it was sent to Spain at the close of the exhibition.

It was not until after the war that the opportunities he was hoping for offered themselves in America. In the Cincinnati 115 mural of 1947, and in the smaller one for Harvard Graduate

The Museum of Modern Art, New York

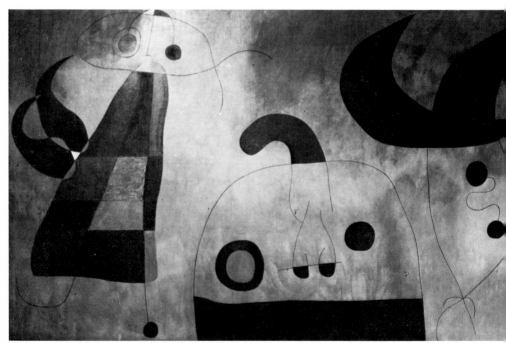

Center (1950), the candour of Miró's brilliant unshaded colour and his masterly sense of design combine with a sense of humour which is both fiercely grotesque and refreshingly light-hearted. His anthropomorphic forms are, in a sense, cosmic and transcendental, yet they move and dance with the abandon of Walpurgis Night. Nothing of the intensity of earlier, more detailed, easel painting is lost in the precision and economy with which the murals are executed.

However, it is in sculpture and ceramics that Miró has found the means to associate his work most closely with architecture, and, in consequence, to involve the public. The two great walls for the Unesco building in Paris, which he completed with Artigas in 1957, the *Wall of the Moon* and the *Wall of the Sun*, 116, 117 are again designs of great intensity in which the technical

115 *Harvard mural painting* 1950–1

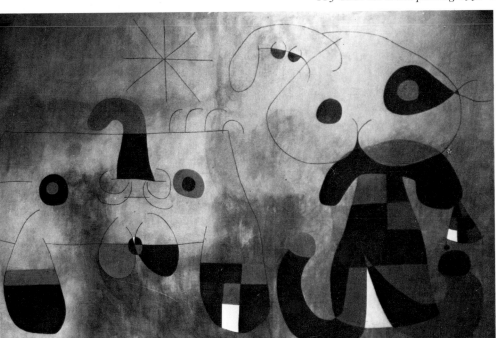

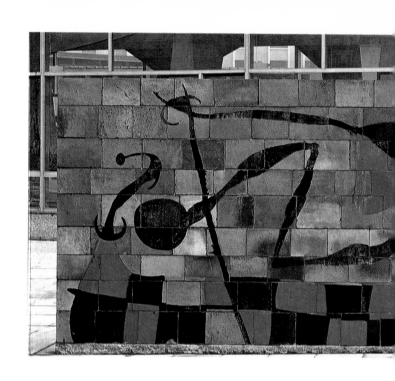

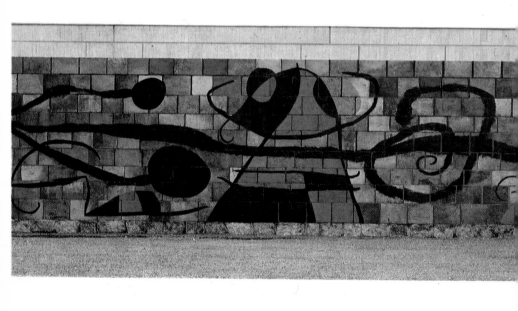

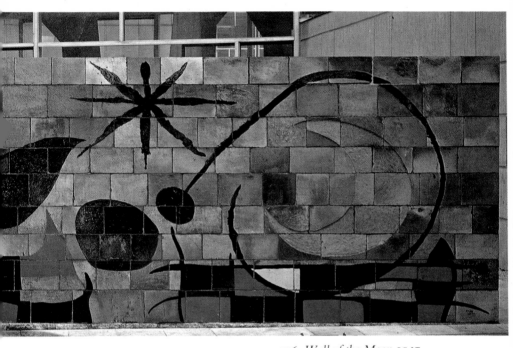

116 *Wall of the Moon* 1957

117 *Wall of the Sun* 1957

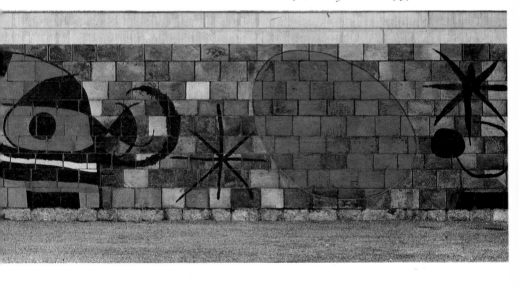

hazards of the art of ceramics have been skilfully overcome. Miró tells us: 'in spite of the precautions that can be taken, the master of the work in the last resort is the fire; its action is unpredictable and its sanction formidable. It is that that gives this means of expression its value.'[3]

The ceramic design that Miró made in 1960 for Harvard University proved once more that his talent, combined with the technical skill of Artigas, could produce very impressive murals. The latest work of this type is to be on an even greater scale. When it is finished, the airport of Barcelona will have a 129 monumental ceramic, fifty metres long by ten high, which will give Miró the scope and the situation in a public place for which he has been preparing himself for many years.

In the autumn of 1968 the citizens of Barcelona at last acknowledged that they had a great artist among them. A retrospective exhibition, showing every category of his work, was held in the great halls of the ancient Hospital de la Santa Cruz. In these surroundings the strength of his most recent work found a natural affinity with the bold simplicity of Catalan Gothic architecture. In the same year, the municipality commissioned two more monumental works in addition to the 118 mural for the airport. A sculpture sixty metres high, sited in the Parque Cervantes, is now to dominate the entrance into Barcelona by the main road from Madrid, while on the Ramblas, which lead from the harbour into the centre of the old city, Miró has been asked to design a pavement. His work in three different manners will now dominate the three approaches – by air, by road and by sea – into his native city.

However, the most impressive group of Miró sculptures and ceramics on a monumental scale has been carefully planned by Miró at the Fondation Maeght at Saint-Paul de Vence. The terraces that mount the hillside, close to galleries designed by José Luis Sert, form a labyrinth richly ornamented by Miró in a variety of ways. The siting of each piece has been planned so that it plays its role in relation to the other sculptures and ceramics among the terraces and the white walls of the buildings.

156

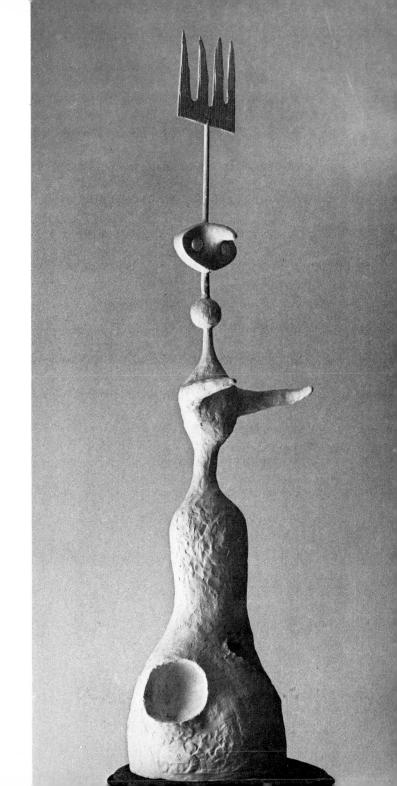

118 Study for a
monument for
Barcelona 1968

Miró has used water, pine trees, terrace walls and the distant panorama of mountains and the sea with great skill. His early admiration for Gaudí's use of natural forms as an integral part of architecture, and the pinnacles and terraces of Gaudí's Parque Güell, richly encrusted with mosaic, have influenced Miró in the dramatic use of nature he has made in the placing of his own sculpture.

119 Many of the sculptures, now monumental in size, were first conceived on a small scale. There are, for instance, a number of diminutive variants of the *Great Arch* which dominates the upper terraces. In the final work, some adjustments in the proportions and a completely new treatment of surface textures, give it the authority of a unique conception thoroughly integrated with its surroundings. From a small plaster model, this has grown into a colossal triumphal arch of biomorphic formation, with allusions to the anatomy of women and birds. It is built in cement, but has occasional incrustations of stone. Before it solidified, Miró incised drawings of stars and other signs which endow its surface with an intimate and decorative significance. The weathering which takes place is accepted by Miró as an ally, even to the welcome assistance of birds that nest in a dark hole in its flank.

120 There is another tall sculpture, *The Fork*, placed on a terrace wall with a vast panorama as its background. In this Miró has been able to induce that marriage between empty space and solid form which is to him a conception of fundamental importance. The construction, in bronze, is composed of three elements. It has a tall, slim body, the surface of which has been enriched with rough patches, as though handfuls of mud had been thrown at its even surface to convince us of its solidity. Above this rises a flat three-sided piece of bronze, in the centre of which a large circle has been cut as a window to the sky. Both these pieces are balanced at their base on curved surfaces, but the fork, which crowns the headpiece like a plume, is even more surprising in its equilibrium. Placed as though on the tip of a vertical arrow it holds the sky in its prongs. The fork is no

158

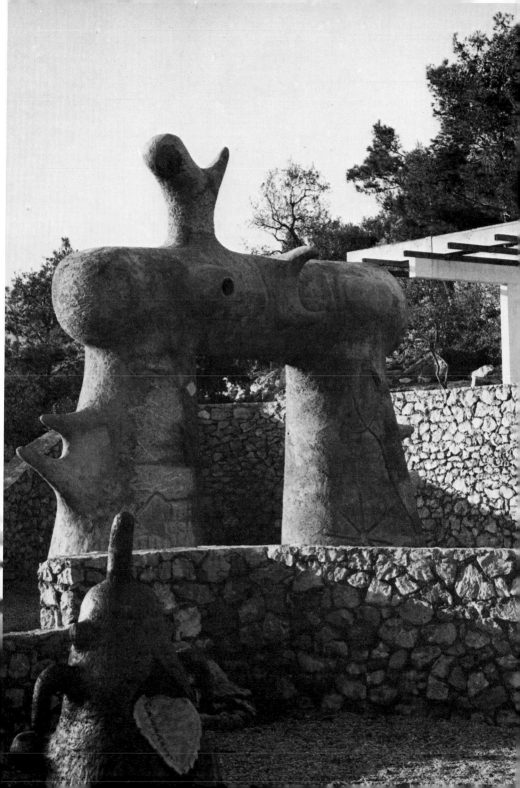

more than a greatly enlarged replica of a Spanish peasant's pitchfork, but in this lofty position it appears to fly into the wind high over the valley like a bird.

Miró enjoys the game of capturing space in a variety of ways. This element, in essence intangible and empty, can be given significance by becoming a sort of magnetic field between objects, or between hands or arms so placed that they control its presence. Miró can, in this way, make something out of nothing. He puts empty space into a cage, or he can give it life as children do, as an invisible head behind a mask with holes cut out for eyes, nose and mouth. He takes every advantage of the fact that our atmospheric space on earth, superior to space on the moon or elsewhere, is filled with air and impregnated with the germs of life. The seashell abandoned by its inmate can still vibrate with sound. A cave, or any gaping orifice, can fittingly suggest the presence of a voice; and the wind can actually invent its own melodies as it plays in the holes and hollows of the great sculptures set up on the terraces of Saint-Paul de Vence.

There is no more evocative trap for catching space than a circular hole such as that in the triangular head of *The Fork*. Wherever it occurs, although essentially no more than a void, the empty circle becomes filled with associations that vary according to its position either as a source of light or as darkness. It may equally well be an eye, a mouth, the sun, an empty bottomless well or the crater of a volcano. Its ambiguity is matched by that of concave and convex surfaces: the convex surface of an eggshell encloses emptiness or the swelling germination of life; but by adding atmospheric colour and signs of movement Miró can give it the transparent depth of the sky before dawn. At Saint-Paul de Vence he has set up a large ceramic, ovoid in shape, so that its dark reflection, mirrored in a pool of water, creates a splendid symbol of the all-enveloping and life-giving mystery of earth, air, water – and even fire, which, in this case, was an element essential to its formation.

160

It was not until 1930, ten years after Miró had become known as a painter, and had developed a highly personal style, that he made his first lithograph; his first etching came two years later. As time has passed he has shown an increasing interest in graphic art, and today his production is so prodigious that there is only one living painter, Picasso, who has surpassed him in the quantity of his output.

There are several reasons for his growing enthusiasm. The most obvious is the natural ease with which Miró's hand flows across the paper. The exuberant enjoyment he finds even in signing his own name with a thousand different flourishes, and the majestic handling of any ornament he may feel inclined to add, makes him a great performer in the art of making signs. Much of this gift comes probably from a natural talent characteristic of the Spanish, the origins of which are to be found in the caves of Altamira. In more recent times it has become a continuous tradition, in the Catalan primitives and in folk art.

In addition there are the many different processes in engraving and lithography which offer scope for inventions produced by unconventional means and new procedures. These again allow him to take advantage of unexpected effects, chance happenings and even mistakes.

121, 122 Graphic art also appeals to Miró's desire to make his work less exclusive, and to overcome the formal limitations of the frame that an easel picture requires. It has the advantage of being less concentrated and more decorative, therefore more popular in its appeal. By offering the public the possibility of by-passing the museum and the exclusivity of the unique work of art, it belongs more widely to the community. Also, its production is often a matter of teamwork among artists and trained craftsmen. This introduces an element of anonymity, which is important to Miró, as it is to many artists.

Whatever technique Miró employs, lithography, etching, drypoint or woodcut, the result is one of extraordinary

freshness. There is a brilliance in colour and variety of texture which arises from his sensibility towards the material on which the print is made, as well as the surface from which it is taken. Miró enjoys making large prints on parchment or on a band of silk. He searches for paper of rare quality which can add a sensuous delight to the print, and mixes his techniques so as to preserve the dramatic surprise of the moment when the print separates, all fresh, from the plate.

There is a series of six large etchings of 1960, *The Giants*, which is typical of the strength of emotion that can be concentrated by Miró in a print. The spontaneity that he has managed in recent years to capture in many of his paintings is present here, with additional life and a magic violence that arises from the ultimate contact between the plate and the paper. The colours are as usual clear. They shine with significant precision through mists of random patterns in black and white. In spite of the poetic quality of his graphic work, Miró does not as a rule give titles to his prints himself; he relies on the sensibility of another poet, Jacques Dupin, to name them.

In the spring of 1969, with another burst of energy, Miró produced a remarkable series of engravings which understand- *124–6* ably he calls 'monumental' on account of their size and the strength of their impact. He developed new processes in which a striking feature is the deeply embossed texture given to certain areas. The prints are astonishing in their vigour, and in the majestic assurance with which he is now able to integrate signs and symbols into three-dimensional designs.

Contrasting the more liquid qualities of colour washes with fine lines engraved with precision, delicate nuances of flat surfaces with the turgid texture of embossed areas, vaporous depth with strong determined shapes in brilliant colour, he presents us with monumental engravings which have an intensity and a richness unparalleled in any former work.

During the same period he also worked on a series of lithographs which are equally successful. By using cloth printed with stripes or check patterns instead of paper, or making use of

dress patterns as his ground, he managed to superimpose his compositions of figures and signs and arrive at results of an amazing variety. The variations on the original themes were accentuated by printing from the same stones in different colours, so that each print has a different appearance. It becomes evident when the prints in the series are spread out together that there can be no final solution. In Miró's hands each version has its own individual and convincing appeal.

The team of craftsmen who had helped in the printing of these graphics have told me of the excitement they felt in working with Miró. After long periods of contemplation, he would plunge into new experiments, inventing unheard-of techniques with complete and unhesitating conviction. If, as sometimes happened, the results did not satisfy Miró, they were torn up at once and a new experiment began. The atmosphere was one of continuous exhilaration and youthful enthusiasm.

Miró's gift for calligraphy, and the ease with which he plays with colour, find a suitable outlet whenever he designs a poster. The brilliance of the colour contrasts, the unexpectedness of the layout, and the flourish with which his posters declare their purpose, attract attention like a trumpet call. When he makes a book cover, an invitation card, or whatever else he may be asked to decorate, there is always a similar conviction. There is strident authority if it is to be sold for a good cause, like the silkscreen print made in 1937, *Aidez l'Espagne*; there is an irresistible gaiety if it is to be reproduced as a gift to his friends. Miró has an unerring sense for the style, the colour, the material that the occasion demands.

It has been said of Miró that he is a 'painter's painter', but he is also a musician's painter, and above all a poet's painter. This made itself evident in his first lithographs, which were made in 1929–30 as illustrations to Tristan Tzara's poems *L'Arbre des voyageurs*. His desire to work in close association with his friends has resulted in an extraordinarily rich output of books of poems by them, decorated with unique ingenuity. Books such as Paul Eluard's *A Toute Epreuve*, Tzara's *L'Antitête* and

62

Parler seul, René Char's *A la santé du serpent*, Michel Leiris's *123*
Bagatelles végétales, René Crevel's *La Bague d'aurore*, Raymond
Queneau's *Album 19* and Alfred Jarry's *Ubu roi* are among
Miró's most brilliant achievements.

But the originality and splendour of these books is matched
by their rarity; they have of necessity been produced in a few
limited editions, and are less accessible than the numerous
prints which Miró has produced. One of his dramatic achieve-
ments in this category was the wartime *Barcelona Suite* of fifty *77*
lithographs. With the renewed possibility of travel after the
war, Miró found that when abroad he could work more easily
on graphic art than on painting, since it needed less continuous
concentration. When he visited New York in 1947, he was
invited by S. W. Hayter to use his studio, and took the oppor-
tunity of experimenting in the new techniques in which
Hayter was particularly proficient. Later, in Paris, the co-
operation of experienced printers such as Lacourière, Mourlot
and Crommelynck allowed Miró to realize his desire to work
as the creative source among a team of highly qualified and
sensitive craftsmen. Recently, facilities offered to him at the
Fondation Maeght have encouraged Miró to produce some of
the most brilliant graphic work of his whole career.

As the years pass, and Miró's activities multiply, he has
systematically apportioned his time between Paris, where he
has all the facilities and the expert assistance he needs for his
graphic work, Gallifa, where Artigas prepares for his arrival
with skill and devotion the raw material for his ceramics, the
studios and workshops at Calamayor, and the remote farm at
Montroig. Calamayor and Montroig are kept free for the
solitary contemplation that accompanies Miró's painting, and
the flashes of inspiration by which he pieces together and brings
his sculpture to life.

121 Lithograph for
Album 13 1948

122 *Small engraving* 1953

123 Lithograph for
Tristan Tzara's
Parler Seul 1948–50

124 *The Great Magician* 1968

125 *In the hail* 1969

126 *The Calabash* 1969

Poetry and reality

Every artist must find in his work his own method of inducing his imagination to take shape, and to develop some initial idea, however trivial, into a work of art saturated with meaning. The idea, according to Miró, comes with the sensation of a shock, the intensity of which is sufficient to initiate a tension of spirit which leads to new emotional activity. He has explained at some length how the process seems to take place. It is important, he insists, that a great variety of incidents should be capable of bringing about this state of mind; but it should not be provoked by 'chemical means such as drink or drugs'. Also, it is unlikely that the same methods will act twice in the same way; if this happened it could lead to the formation of a system, and this would impair or destroy the spontaneity which is an essential element in this process. It is only through the uncharted channels of the subconscious that the main stream of inspiration can flow freely.

'I work better when I am not working than when I am', he told me, 'like Saint-Pol Roux who used to put a notice outside his door, LE POÈTE TRAVAILLE ['The Poet works'], when he intended to sleep.' But the tension that gives birth to ideas can also come through incidents and surprises which happen when the artist is wide awake, or during the long hours when he contemplates objects which may become particularly charged with interest.

'The atmosphere which favours this tension', he told Yvon Taillandier, 'I find in poetry, music, architecture – Gaudí, for example, is terrific – in my daily walks, in certain noises: the noise of horses in the country, the creaking of wooden cart-wheels, footsteps, cries in the night, crickets. The spectacle of the sky overwhelms me. . . . Empty spaces, empty horizons,

empty plains – everything that is bare has always greatly impressed me.'

But the atmosphere is productive only when it somehow provokes a deep, urgent reaction. 'I work in a state of passion and compulsion. When I begin a canvas, I obey a physical impulse, a need to act; it's like a physical discharge. . . . I begin my pictures under the effect of a shock . . . which makes me escape from reality. The cause of this shock may be a tiny thread sticking out of the canvas, a drop of water falling, this print made by my finger on the shining surface of this table. In any case I need a point of departure, even if it's only a speck of dust or a flash of light. This form begets a series of things, one thing giving birth to another thing.'[1]

From the moment when the initial shock has set the imagination in motion another process follows. 'I have always felt that I am like an insect with antennae,' Miró told me. 'I hover and find myself directed mysteriously to further discoveries.' But once the contact between him and his work has been established, the discoveries come from chance happenings in the work itself. A continuous feedback takes place from the work which has already gained a life of its own.

The process, however, is not necessarily continuous. In his studio Miró keeps round him scores of canvases in all states of progress, some scarcely begun and others awaiting, possibly for years, the moment when that communion between him and his work will allow him to establish the final state of tension he wishes it to contain. When this has happened, there follows a feeling of detachment and a shift of interest from the finished work to younger, less developed members of the family that he is constantly bringing to life.

In spite of his distrust of all systems, Miró counts on certain sources on which he habitually relies for stimulation. In addition to chance happenings and the unlimited sources of nature, he keeps round him a stock of objects, each containing some provocative significance, and images cut out from magazines and pinned to the wall, remarkable either for their fantasy

or their banality. Between this raw material and the finished work, of which sometimes they may bodily become part, lies a path paved with hesitations and uncertainty. Stacks of canvases of all sizes, in varying states of preparation, and half-finished sculptures, wait round him like cultures in which the imagination can germinate. Meanwhile, they are still at work in Miró's mind, although dormant for an unpredictable time.

Occasionally, a blank canvas receives the first traces, sketched lightly in charcoal, of an idea which will perhaps be left for months to develop until the moment comes when Miró feels clearly the exact shape of the dominant lines and the colour that is to be their accompaniment. Or it may be that, when finishing work for the day, Miró will wipe his palette-knife, his hands or even his feet on a new canvas, leaving a pattern of coloured blobs, stains or footprints on its surface. Accidents such as these are essential opening gambits which provoke new trails of thought and open unexpected doors to the ·imagination.

Miró's observation is not necessarily confined to chance or to nature, although these provide unlimited resources. Just as *39, 40* he found his inspiration for the *Dutch Interiors* in the seventeenth-century paintings in the museums of Holland, he may find a sudden interest in the banality and false values of a commercial reproduction and proceed to transform it by adding to its surface the vigorous signs that emerge from the fleeting reality of his dreams, or he will select a thoroughly insincere and trivial landscape painted by an obscure artist and, in reaction to its vulgarity, he will joyously paint it over with a strong rhythm of black lines and flat colours. The result is a new and fantastic reality that forms a strange marriage between inadequate representation and powerful poetic symbolism.

In a different mood, Miró has taken as his point of departure *127* a landscape of Château-Thierry by Corot in which a small accent of colour, the red hat of a figure seated by a river, gives meaning to the sensitive greens, greys and ochres of the whole composition. There were three factors in the Corot that

triggered off Miró's enthusiasm and resulted in a large canvas, *Homage to Corot* (1968). The first was the piquant economy in *128* the touch of bright red, the second the shape of a clump of trees surrounding a house in the middle distance, and the third the grey sky. The foreground shadow he characteristically transformed into impenetrable blackness. Otherwise the complete liberty with which Miró set to work removed his version so far from the original source of inspiration that it is only by the title that the connection still remains.

Miró's way of finding another point of departure in collage is well illustrated by the way in which he derived the series of great paintings of 1933 from the catalogue of a hardware store. It has often been in the annihilation of literal images and their translation into poetic signs that Miró has enjoyed a sense of elation and freedom, but not infrequently an image banal or sentimental in itself is allowed to play its part intact. Its incongruous presence brings a reference to the reality of our daily preoccupations in sharp contrast with the fantasy of the surrounding forms.

Miró's capacity to utilize borrowed images and recognizable objects goes beyond two-dimensional art. He finds a wide field for the transformation of objects into sculptures which contain *105–7* new, often grotesque, personalities. He collects a great variety of derelict objects which intrigue him by some hidden significance. As his friend Prats says: 'When I pick up a stone, it's a stone. When Miró picks up a stone, it's a Miró.'[2] The corners of his studios are crowded with rusty pieces of iron, twisted wires, bones, broken electric bells, horns, old roots, stones, pots, peasants' tools and pieces of tinsel. I have watched him try out various combinations and suddenly, seeing a solution that fascinates him, build up from pieces of scrap a figure with a strangely convincing personality – a chimera, benign or evil in character, but essentially humorous. Unexpected encounters between objects such as he brings about are always humorous, and yet are also part of the solemn magic game at which Miró is an adept.

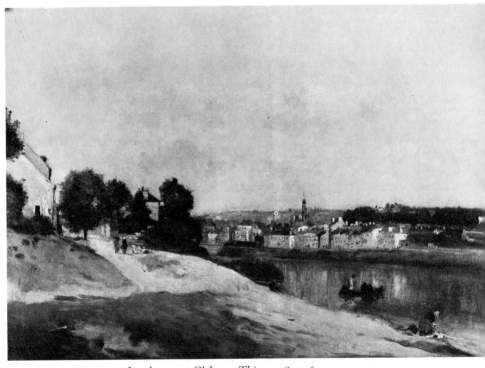

127 CAMILLE COROT *Landscape at Château-Thierry* 1855–65

In spite of Miró's method of working on many paintings and sculptures concurrently over a long period, there is a consistency in each work, due to the patience with which he waits for the moment when the material speaks to him and reveals the means by which he can bring it fully to life. Accidents and the shock that accompanies them are the most unfailing means of creating that tension of the spirit which he recognizes as being essential. 'I work like a gardener or a vinedresser,' he

128 *Homage to Corot* 1967

told Yvon Taillandier. 'Things come slowly. My vocabulary of forms, for example – I didn't discover it all at once. It formed itself almost in spite of me. Things follow their natural course. They grow, they ripen. I must graft. I must water, as with lettuces. Ripening goes on in my mind. So I'm always working on a great many things at the same time.'³

There are days of taking in, of absorbing sensations, just as there are days of giving out, and it is Miró's patience and the

solitary concentration of his whole sensibility that reward him with a spontaneous and vigorous renewal of his inspiration. 'Every day I risk my neck,' he repeated to me, categorically.

There are, however, demands which call for a method which cannot be left entirely to spontaneity. On several occasions Miró has accepted a commission for a monumental work and has operated in a more calculated way. When he was asked to execute the vast mural at the airport of Barcelona, his first step was to spend, alone on the site, several days and sleepless nights. It was the absence of a conversation with a work already taking shape that made the task much harder, since he must not allow his finished calculations to overwhelm the element of spon-

129 taneity. Finally, when he began to work on a maquette laid out on the floor of his studio, it was completed in bold outline and brilliant primary colours in the space of half an hour. The result was powerful and definitive, and Miró was satisfied not only by the admirable simplicity of his solution but also by the knowledge that the process of translating the maquette into a ceramic fifty metres long by ten metres high, on which he was about to begin work with his friend Artigas, would inevitably reintroduce an element of chance. In the firing of the hundreds of tiles required, slight variations in colour and texture would again bring unexpected detail and the incalculable presence of life.

TITLES

The skylark's wing encircled by the blue of gold rejoins the heart of the poppy that sleeps on the meadow adorned with diamonds: this

130 is the title of a large painting of 1967 which appears at first to be an abstract composition. But Miró tells us that although he never starts a painting from a given title he often discovers a title, more or less elaborate, at an early stage. 'I find my titles gradually as I work, as I link one thing to another on my canvas. When I've found the title I live in its atmosphere. The title then becomes a hundred per cent reality for me, like a model – a

reclining woman, say – for someone else. For me the title is an exact reality.'[4] This unusual process, in which a painting becomes linked with, and in some ways dependent on, a poetic idea, should be understood if we are to enjoy Miró's work to the full.

If we look again at the painting I have just mentioned, bearing in mind its title, new elements come into play. The lark's wing has acquired a blue aura from the sky, and we now realize that we are enveloped in golden light, looking down from a height at a small scarlet poppy which illuminates the space round it like the sparkle of diamonds. The title becomes a poetic accompaniment to the painting and also supplies an interpretation of colour and space that extends and completes their effect.

What follows is more than an eyeful of colour. Our vision is accompanied by a giddiness when we realize we are no longer on the earth but enjoying the exhilaration of the lark, detached, looking down and astonished at the brilliance of one small red flower in a great expanse of green grass. Instead of offering purely abstract visual pleasures, title and painting now create together new metaphors for space, movement and the life of the fields.

There are many other instances in which the title provides a new element when read with the picture, but in some cases the title is incorporated into the painting itself. In *Le corps de ma* *32* *brune* . . . (1925), the inscription covers the whole canvas in such a way that the words play a major part in the composition, a method also used by Max Ernst. In a recent painting the *131* stencilled letters of the word 'silence' are scattered over a large red patch in the centre in such a way that as we read them the repetition of the 'E' seems to evoke distant echoes – echoes that are taken up by other signs that we find repeated with diminishing size into the distance. It is as though we had shouted S I L E – E – E – N C E within some vast echoing hall, and it is typical of the reversals of positive and negative that Miró so often uses that silence should be the means of creating sound.

129 Maquette for Barcelona airport mural 1969

But although Miró is highly sensitive to music, and has given
79 titles to his paintings such as *Dancer listening to the organ in a
Gothic cathedral* or *Woman listening to music*, he realizes that any
reference to sound in painting is bound to be ambiguous. He
always works in complete silence, but the influence of music
can be felt in his painting in the vibration of lines or colours.
131 In the painting entitled *Silence*, he has arrived at a more literal
metaphor.

In contemporary art the title has often been condemned as a
literary impurity unnecessary for the appreciation of the visual
arts. Abstract painters such as Mondrian have preferred to
number their works or use the title merely as a means of
identification. Traditionally the title has been little more than
a description of the content of the painting, with some notable
exceptions such as Goya's titles for *Los Caprichos*, which are
intended to extend the allegorical element.

The surrealists deliberately began to override the barriers
between poetry and painting, and chose to do so in ways which
were ambiguous and calculated to provoke the imagination by
their incongruity. However, in his early work, during the
period of his closest association with the surrealists, Miró took
little interest in titles. Like Picasso, he found that a painting can
speak for itself, though in some cases a title asserted itself or
was invented by his friends. It was about 1930 that titles, apart
from those written on the canvas as part of the composition,
began to become a feature of importance.

Owing to the way in which he now works, the title emerges
out of the unfinished painting; it becomes, as he says, his model
– an invisible idea takes visual form. This reaction between
different but inseparable kinds of imagery enriches his work
with surprising and unorthodox metaphors. A list of his titles
could be enjoyed as a poem; but this is not their purpose. They
are accompaniments intended to intensify the lyrical atmo-
sphere, or subtly to extend the dimensions of the work, and
as such they should always be read attentively as part of the
picture.

If we should wish to select one theme which dominates the work of Miró more than any other, the night could, for many reasons, be chosen and made his emblem. This is the coat of arms in which Miró most readily clothes himself, and by which we can identify and recognize the dominant characteristics of his power to captivate us.

In the 1920s Miró had found a generous source of inspiration in that phenomenon of the night, the dream, and had transposed the immeasurable influences which stir in the subconscious into the conscious realm of our waking hours. His friends, the surrealist poets and painters, discovered in him an Orpheus who could go into the underworld of night and, unscathed, bring out mysterious signs – who could give evidence of the indissoluble links between the world in which we move and are conscious, and that unknown world which none the less envelops and influences us – who could bring together the luminous world of day and the sombre realm of night.

This does not imply that Miró is obsessed with obscurity and darkness. He is far too conscious of the light and the vital colour of the world in which we live. It is his appreciation of the contrast between night and day that raises him to an unique position – his consciousness that the night, which can present itself as the symbol of death, is also the womb of creation, that grass grows by night, and that, strangely enough, physically we can see further by night than by day, for by night the stars, chosen by Miró as his most persistent symbol, can appear to be close at hand, while by day they are invisible.

While the light of day reassures us of the identity of the world around us, night is rich in ambiguities and confusions that upset our confidence. On the one hand we can find solace in the silent calm of night: we are warmed by the embrace of love and the confidence of sleep; we rejoice in the fecundity peculiar to the hours of darkness, the time of conception and of growth, and in the visions to which night gives birth in the imagination.

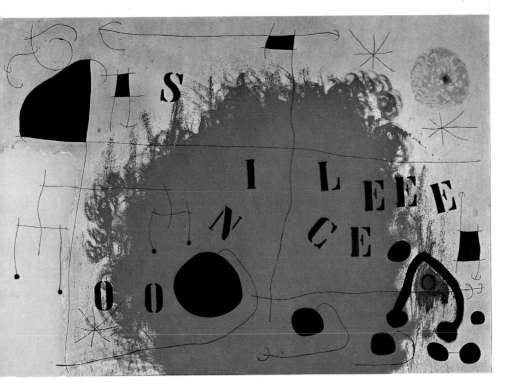

131 *Silence* 1968

Yet, beside all these delights, there lurks the terror engendered
by the night, isolation, blindness, the nightmare, the demons of
uncertainty and the semblance of death.

Darkness can surround us like the walls of a prison, and yet
the prisoner waits for night to make his escape. Night closes in
on us, and yet space becomes more vast and limitless around us.
Our sense of distance becomes unsettled. Pygmies become
giants, and our normal sense of measures and proportions
suffers bewildering distortions. Time also changes its rhythm;
the brief passage between sleeping and waking can seem endless
in our dreams. But whether we are asleep or awake, the night
carries with it a condition which is more primeval than the day.

183

130 *The skylark's wing encircled by the blue of gold rejoins the heart of the
poppy that sleeps on the meadow adorned with diamonds 1967*

Our sensations are closer to the source of consciousness, to primitive fears, hopes and memories, than the rational control of our waking hours will permit.

Miró has appreciated the value of the night, above all for the spiritual freedom that it offers, and for the ambiguities and contrasts it implies. The escape it affords from the tyranny of everyday affairs, and the vision that rewards us when only the eye of the imagination is active, become apparent in the manner in which he interprets his inspiration. He gives substance to visions that have their source in the subconscious – visions that are most vivid when the liberating influences of sleep and the night envelop us in a solitary trance.

His love of the unattainable, his mystic marriages with the stars, are passionate and enduring emotions, but the medium he uses is visual, finite and more direct in its appeal. In our time the solitary transcendental love of the mystic has become a rarity; the dark night of the soul is disturbed by the glare of modern technical discoveries. Miró is essentially modern. His sensibility extends from the primeval magic of the cave paintings to the banalities of factory-made objects. It is understandable that for him and for us, the dark night should now be illuminated with brilliant colour and the clash of contradictory ideas. The night of Miró reflects the realities of our age.

Nor does Miró necessarily think of the night in subtle metaphysical metaphors. As an untiring observer he says: 'I'm overwhelmed when I see, in an immense sky, the crescent of the moon, or the sun,' and adds: 'In the contemporary visual climate, I like factories, nocturnal lights, the world seen from a 'plane. I owe one of the greatest emotions of my life to a night flight over Washington. Seen from a 'plane a city is a marvellous thing.'[5]

A glance at the titles that form accompaniments to Miró's paintings will convince us of his interest and give us clues to those things associated with the night that enchant him most. There are mysterious nocturnal happenings (*A drop of dew, falling from the wing of a bird, wakes Rosalie, asleep in the shadow*

of a spider's web); amorous encounters (*Numbers and constellations in love with a woman*); magic influences (*People, magnetized by the stars walking on the music of a furrowed landscape*); secret intimacies (*Woman with a blonde armpit dressing her hair by the light of the stars*); romantic tenderness (*The nightingale's song at midnight and morning rain*, and *By moonlight the setting sun caresses us*); allusions to the return of the light (*The mauve of the moon covers the green of the frog on the departure of darkness, Hope comes back to us as the constellations flee*, and *The blaze of the sun wounds the lingering star*). 75 85 82

Above all the presence of woman dominates Miró's night. There are *Women and kites among the stars*, *Women and little girls skipping by night* and *Women with dishevelled hair welcoming the crescent of the moon*. There are rites celebrating the presence of woman throughout the night: *Birds and shooting stars encircling a woman in the night* and *Woman hypnotized by rays of twilight stroking the plain*, and a number of paintings entitled *Women and birds in front of the moon*. 133

Often the presence of a woman is accompanied by the 'bird of night', not infrequently in close association with flight from the constraints of day: *The star rises, the birds fly away, people dance* – while elsewhere there is a *Woman dreaming of escape* and near by *The Ladder of Escape* and *The Passage of the Divine Bird*, or, again, *The wings of the bird slide over the moon to reach the stars*. 78

Such titles in themselves give insight into the tenderness and the alarm with which Miró has examined nocturnal activity. From twilight to dawn, the night becomes a stage, set for a strange cosmic drama in which creatures of the night, the snail, the bird of night, the frog, the spider, exchange places with the stars and the moon in a festive celebration of woman: 'A star caresses the breast of a Negress'. There is a nocturnal indifference to the recognized magnitude of all things. The boundless space that first appears in the early 'dream paintings' confirms the sensation that the night accentuates a consciousness of the infinity of space and that darkness, far from being merely 65

the negation of light, contains every imaginable colour. Miró's night skies are often white, and the stars, the moon, even the sun, become black or laden with colour.

Although this preoccupation with the night is more obvious in paintings since the *Constellations* of 1940–1, we find deliberate 17 reference to the allegory of night and day in *The Farm* as early as 1921–2, where the immaculate disc of the sun, set in an immense blue sky, finds its echo in the black circular shadow in the earth at the foot of the tree. In this bond between positive and negative polarities the great tree finds the direction of its growth from darkness to light. In other paintings, such as 36 *Dog barking at the moon* (1926), Miró treats the night as an observed phenomenon rather than as an atmosphere in which we become immersed, and we find here an early appearance of that symbol that later recurs so often, the ladder of escape which leads deep into the solitude of night. But it was in the 'dream paintings' of 1925 onwards that a new preoccupation with night began to develop. Limitless space, inherent in darkness, and the atmosphere of sleep found a new emphasis in his work. Dreams and hallucinations – influences contrary to the hard facts of daily life, but emanating from the subconscious – entered into his painting with the freshness of dew. The vast empty spaces he created, detached from all reference to earth or the horizon, became populated with shapes related to the phantoms that appear in states of half-consciousness.

As the political atmosphere darkened, and Miró's painting became prophetic of approaching catastrophes, he found in 47, 48 the great compositions of 1933 the means of enveloping the spectator in an atmosphere of primeval night. We are led into vast caves inhabited by magic animals, a twilight in which creatures of darkness float and dance, not on the ground but among the stars. His disquiet increased and made itself felt 56 dramatically in his *peintures sauvages*, in which the skies behind grotesque figures of men, women and monsters become opaque with the blackness of a sinister and artificial night. The turbulent darkness that was descending culminated in the

186

Still-life with an old shoe (1937), that powerful allegory of civil *60*
war. With great eloquence, Miró used black as a colour in
several paintings such as *Woman's head* (1938), in which the *64*
image of woman suffered cruel metamorphoses, appearing as
a monster of the night, black and yet adorned with the brilliant
regalia of her attributes.

The night in its many aspects is not, however, in itself evil. It
is capable of harbouring, even during Miró's most heart-
breaking years, an assembly of gay and scintillating creatures
presided over by a star, as in *Nocturne* (1938). *132*

During the first tragic weeks of the Nazi invasion of France,
it was in this more lyrical mood that he produced that very
beautiful and poetic series of small paintings, the *Constellations*, *71–76*

132 *Nocturne* 1938

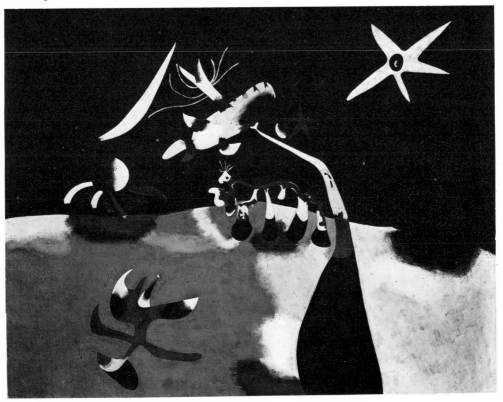

which are fundamentally an ode to the night from twilight to dawn, an ode to its population of nocturnal creatures, the dew, the nightingale, the stars. Talking of this a few years later, he said: 'I felt a profound desire to escape. I deliberately withdrew into myself. The night, music, the stars, began to play a major part in suggestions for my pictures.' Throughout this brilliant series, woman is supreme, encircled by her lovers, creatures of darkness, the birds, the stars.

In the paintings that follow, like *Women and bird under the moon* 133 (1944), night is no longer dominated by the evil obscurity of war and terror. It has borrowed from the dawn the colour of courage; people dance, once more refreshed by the coolness of the night. With the power of a magician, Miró fills the night sky with light, knowing that the night is not blind, that we can see in darkness, and that, on the contrary, it is the light that can blind us. Miró sees by night, his darkness is flooded with colour and infinite in its space. In a painting of 1953 a sun, black as night, appears beside a dark star. In a masterly way he succeeds in revealing to us a conception of space that unites the dichotomy of night and day.

The three large canvases of 1961, *Blue I, II, III*, illustrate 95 this unity very beautifully; but no painting can convince us better than the more recent works of 1968 which appear to be an ultimate refinement of this same theme. They were first shown, most appropriately, on three walls of a small Gothic chapel. The title given by Miró to this triptych is *Mural paintings for a hermit's cell*. Each of the great canvases has no more than a single tenuous black line that crosses its immaculate whiteness, and in each case this happens with a different motion. To follow its course inch by inch is to accompany a determined explorer crossing a vast, empty but luminous space. If, however, we imagine this seen in negative, we have a white line moving across a totally black sky, like a flash of lightning. But Miró's version, the negative of the storm by night, is even more dramatic and more stimulating to the imagination – it is the triumph of light over darkness.

133 *Women and bird under the moon* 1944

134 *The Solar Bird* 1966

Among Miró's recent sculptures there are two large pieces of 1966 which evoke the theme of day and night: *The Solar Bird* and *The Lunar Bird*. Both these works exist in two versions, one in bronze and the other in pure white marble. Here the darkness of the bronze version, with its star-like reflections of light, is more evocative of the roles that Miró attributes to these two astral bodies.

135 *The Lunar Bird* 1966

Of the two figures, 'ageless toys astonished to see themselves suddenly promoted to the dignity of idols',[6] the sun bird, surprisingly, is considerably the smaller but clearly contains a greater degree of energy. His movement is horizontal and of great vigour, driven from the rear as though by jet propulsion. He appears to be eternally active, busy like a man determined never to be late in his daily round of appointments; practical and steadfast, he carries on his back a crescent moon.

In contrast the moon bird is wayward and variable, a bird without wings. She seems more firmly attached to the soil, and is dominated by an upward growth which culminates in two great horns that sprout from the ripening crescent of her head. Always, whether she is causing the dog to bark, presiding over woman, making the ocean pulsate or being bleached out by the dawn, Miró attributes to the moon a greater mystery than to her companion the sun, more monotonous in his habits. Queen of the night, she rules mysteriously; her influences are disconcerting, her course erratic. Yet all female creatures obey her, and in the realm of dreams she is supreme.

It is commonly known that all cats are black at night, and this knowledge might encourage us to think that Miró loves the night for its anonymity. 'We must move towards anonymity,' he tells us, 'Today we are more and more aware of the need of it. But at the same time we are aware of the need for an absolutely individual gesture, completely anarchic from the social point of view. Why? Because a profoundly individual gesture is anonymous. Being anonymous, it allows the universal to be attained, I feel sure: the more local anything is, the more universal.'[7]

In these words Miró expresses the union between solitude and universality that can be felt above all at night. But this brief examination of his work should be sufficient to convince us that for him the night does not envelop everything in a formless, colourless, intangible haze; on the contrary, he knows the varied characteristics of the inhabitants of night intimately, their explosive brilliance and the absorbent depth of their

shadows. Among the many enchantments revealed to us by his genius he shows us the thousand eyes and the multitude of wonders hidden in the immeasurable scope of night, that short passage between the light of two successive days which neverthe less occupies a very large part of our lives. In the words of an ancient Hindu sage:

> That which for all men is the night,
> In that, the poet is awake.
> And in that in which all men are awake,
> That is the night for the poet.

THE LADDER OF ESCAPE

The ladder, that simple device which allows us to rise above the earth, gather fruit or hide away in the branches of a tree, made its first appearance in Miró's paintings in *The Farm* (1921–2). Beginning with its literal representation in this picture, the ladder was soon endowed with a wider significance. In *Harlequin's Carnival* (1924–5) it leads us with its tapering perspective into regions of fantasy where elegant creatures shaped like mermaids float out from between the rungs. In *Dog barking at the moon* (1926), the ladder leads out into an empty sky, while in many other paintings such as *Une étoile caresse le sein d'une négresse* (1938) it has become a purely schematic sign which penetrates into the unknown. Its shape is made to imply movement, an invitation to follow the direction in which it points, to rise beyond the limitations that bind us to earth, to escape from the material world into the realms of the spirit. The symbol has been used persistently by Miró because of its power to describe graphically his own desire to transcend the incomplete condition of daily life.

In earlier years Miró's close contact with surrealism had already convinced him that art, if it exists at all, implies something more than the enjoyment of beauty. His investigation of the world of dreams and the subconscious was made with

17

20

36
65

78

the desire to approach, to use Herbert Read's term, 'the frontiers of perception', regardless of the risks involved. There has never been any doubt in his mind that what is of real importance to him lies beyond painting. The degree of sheer visual pleasure that paintings give can be intense; but the more acute it becomes the more it is likely to provoke a further yearning, often ill-defined but of great strength, for a transcendental understanding of our condition. The work of art then, as it leads us to the frontiers of perception, becomes the medium which can give access to new states of consciousness. In itself, though it remains the motive force, it becomes less important than the state of mind to which it leads. At the same time the artist himself also recedes into a condition of anonymity. 'Anonymity', Miró says, 'allows me to renounce myself but in renouncing myself I come to affirm myself more strongly.... The same practice makes me seek the noise hidden in silence, the movement in immobility, life in the inanimate, the infinite in the finite, forms in space and myself in anonymity.'[8] Artists such as Miró, who have discovered through paradox that the finite statement of their work can be a gateway to a new perception of the infinite rather than an end in itself, accept the role of prophet, or rather seer. They become the intermediaries who, instinctively in the first place and later by their command of aids and techniques, can carry us with them into a more complete understanding of our human relationship to the great unknown, towards an accord between us and the nature of all things.

Hindu philosophy tells us that 'he who understands has wings'. The idea of flight as a symbol of liberation is widespread. It is tempting to find a similarity between the atmosphere created by Miró and shamanic rites in which the adept is able to visit the celestial paradise and describe to his audience in detail all he sees and all that happens. The importance of this is the primitive conception that it is necessary for the seer not only to see beyond our usual limits and restore to his audience contact with the transcendental, but also to perfect his means of

doing so. His means of entering into a state of ecstasy will inevitably involve symbols and metaphors. The shaman takes imaginary wings, mounts from the earth by means of a tree or a liana, or, as in Siberia, climbs up a post in the middle of the tent and out by the smoke-hole. 'But', according to Mircea Eliade, 'we know that this opening, made to let out smoke, is likened to the "hole" made by the pole-star in the vault of Heaven'[9] – an elementary but vivid metaphorical description of the transcendental process.

These yearnings arise, wherever they occur, from the necessity for a liberation from the bonds of the material world; a universal means of attaining this transcendence is found in the use of symbols born from a state of trance. The universality of the symbols implies that they belong to the collective unconscious. They are the product of a trance state which resembles the paradisaic condition attained by the shaman through his rites. For him 'sacred stones or trees', to quote Eliade, 'are not adored in their natural capacity, but only because they are *hierophanies*, because they "show forth" something which is no longer mineral or vegetable but sacred – "wholly other".'[10]

We can recognize in this primitive conception Miró's belief in the necessity for metamorphosis, an idea which dominates also the writings of Antonin Artaud whom Miró remembers as one of the most important influences in his early friendship with the surrealists. In his book *Héliogabale*, Artaud pursues this ancient belief. 'I mean to say', he writes, 'that in Syria the earth lives and that there are stones that live. . . . There are black stones in the form of the penis of a man with a woman's sex chiselled below. Such stones are the vertebrae in the precious corners of the earth. . . . But there are stones that live as plants and animals live, and as it may be said the sun lives.'[11]

The daemonic writings of Artaud were accepted by Miró in a manner that worked deeply on his imagination. Ideas born from them continue to appear years later, as for instance in the great ceramic *Woman and bird* (1962), which has embedded in *136* its upright phallic shape a bold symbolic representation of the

vulva. This is not a literal illustration of the black stones mentioned by Artaud; it is significant as a sign of the animistic conception of the world which Miró shared with his friend. 'It is the spirit of a stone that acts. The stone itself is without value,' he told me, and went on to describe his last visit to Artaud when his friend was a mental patient at the Hôpital Sainte-Anne in Paris. Artaud, who was then a very sick man,

136 *Woman and bird* 1962

seized an axe in the hospital garden and with terrifying cries began to cut down a tree which to him had become an embodiment of evil; this scene troubled Miró profoundly. An act of such frenzied violence was completely foreign to his nature, but he recognized at its source the same animism which he shared with the poet.

The vestiges of primitive understanding that we inherit in myth are all inseparable from an element of mystery – a form of understanding which convinces us but cannot be explained logically. Miró has often expressed a great admiration for the poetry of Stéphane Mallarmé. The work to which he feels most closely akin is that unprecedented and enigmatic poem 'Un coup de dés jamais n'abolira le hasard', in which the poet scatters lines and words across the page, taking into account the visual importance of the white spaces between them. In his preface to the poem Mallarmé says: 'The paper intervenes each time an image ceases or enters of its own accord.'[12] The last lines of the poem express a conviction of the intrinsic value of doubt, meditation and chance:

veillant
 doutant
 roulant
 brillant et méditant

 avant de s'arrêter
 à quelque point dernier qui le sacre

 ·Toute Pensée émet un Coup de Dés

('. . . watching/doubting/wandering/shining and meditating/ before coming to a stop/at some final point that consecrates it/ Every Thought emits a Casting of the Dice.') Like Mallarmé,

197

Miró knows that we see furthest when we perceive things as though through a veil which cannot be lifted entirely and by which the imagination is nourished and made active. At the poetic level we see and we interpret, but must never destroy what we have seen and felt by saying too much. There is a region, midway between the disintegration of chaos and the sterility of infallible order, in which life exists. It is at this precarious level that Miró opens our eyes and provides access to new regions. He does not propose that we should struggle to attain either hell or heaven, but rather to gain a truer understanding of their coexistence and our own relationship to both extremes. Miró shows us at every turn that it is not the sublime that leads to the transcendental; the reality of material things can provide the starting-point for our voyage of escape – a voyage which is essentially creative and valid as an experience, because it is spiritually and materially the ultimate symbol of life. R.D. Laing, approaching this conception from the point of view of the psychiatrist, says: 'Man, most fundamentally, is not engaged in the discovery of what is there, nor in production, nor even in communication, nor in invention. He is enabling being to emerge from non-being.'[13] Miró, in his early belief that art must emerge from anti-art, already recognized the existence of this fundamental truth. In its later developments his anti-art has become the medium, the experience transcending himself, which can be shared by all.

REALITY

Miró's evolution from an artist closely attached to peasant origins, seeking to represent nature with an almost pedestrian realism, to a seer whose aim is a transcendental escape, suggests paradoxically that there is a parallel between him and Mondrian, for whom he expressed such contempt in early days. In a recent letter to me, Miró explained his present attitude. 'I have a profound respect for Mondrian. Although we are at opposite

poles, he takes things to their limit and sacrifices everything to attain purity. He leaves the dramatic realism of his first period to arrive at this saintliness. His influence is widespread, but he should remain a unique case in the history of art. As for me, the more ignoble I find life, the more strongly I react by contradiction in humour and in an outburst of liberty and expansion.'

It is here that we find once more the importance of contradictory elements to Miró himself; we recognize his love of paradox, and the stimulus he gains from adversity. Elsewhere, this painter who has enchanted us so often by the brilliance of his humour confesses that by nature he is tragic and taciturn: 'I am a pessimist. I think that everything is going to turn out very badly. If there is anything humorous about my painting, it has not been consciously sought. This humour comes perhaps from the need I feel to escape from the tragic side of my temperament. It's a reaction, but an involuntary one.'[14]

The humour of Miró often has a flavour of violence, and frequently evokes a sense of cruelty which is highly disturbing. In that way it is essentially Spanish. His attack on the human image, both visual and conceptual, is devastating and fundamentally akin to the violent distortions of Picasso. But in a less violent mood the contortions and expressions of his figures provoke laughter by their innocent buffoonery; and laughter caused by the grotesque, Baudelaire tells us, 'has about it something profound, primitive and axiomatic, which is closer to the innocent life and to absolute joy than is the laughter caused by the comic in man's behaviour'.[15]

Humour is after all a means of lifting us from one plane to another, and offers a form of escape. Miró uses it instinctively to lead us beyond the trivial, knowing that the universal fund of banality and triviality that surrounds us is the raw material from which he must draw. It is here that he has never lost the peasant wisdom that he expressed by saying: 'it is essential to have your feet firmly planted on the soil in order to leap into the air.'

The paradoxical nature of Miró's attitude to the real is further illustrated in his artistic relationship with his great contemporary and compatriot, Picasso. Both artists feel a compulsion to question their own achievements; their careers illustrate the saying of Max Jacob, an early friend of both painters: 'le doute, voilà l'art!' ('Doubt: that's art').[16] The element of doubt which acts as a stimulus towards new achievements becomes a salutary torment from which it is impossible to escape. It eliminates the deadly possibility of self-satisfaction and sharpens perception and poetic insight.

While discussing some of his own paintings recently Picasso said: 'Like all Spaniards I am above all a realist.' His statement should, and in fact does, apply to Miró; but we know also that there are many different interpretations of reality, each allowing its interpreter to be called a realist.

A definition of the realism of Picasso is difficult because in the variety of his styles there is a disconcerting disparity between, for instance, his cubist paintings and the work of his neo-classical period, in which the method of representing form is more conventional. It is however always possible, even in his most hermetic style, to trace a relationship back to some objective observation. Picasso's imagery always originates in his acute and penetrating ability to observe the world around him, even though it may become surprisingly transformed in the process of creation.

The same approach to painting was inherent in Miró and is clearly visible up to the time when he painted *The Farm*, but from then onwards he began to rely progressively on the reality of his dreams and the fecundity of an imagination which was constantly receiving nourishment both from the subconscious and the outside world. This approach led to a new sense of reality which transcends a literal representation of objects and finds its expression in signs and symbols which attain a universal or archetypal meaning.

To illustrate the difference between these interpretations of reality we have only to look at the two murals, *Guernica* and *The*

Reaper, painted by Picasso and Miró at the same time with the same cause, Republican Spain, at heart. In taking the destruction of Guernica as his subject Picasso chose an event of great emotional significance. The symbolism he used was directly inspired by the reality of the tragic bombardment and its victims taken by surprise during their daily occupations. *The Reaper*, although it is undoubtedly related to Miró's love of his native soil and its courageous people, is based on allusions that are detached from any precise person or event. Its appeal has a timeless dimension – a sense of space open to the ethereal voyage of the spirit beyond the limits of our material existence. The reality of Miró's painting exists in the dreams and desires of the imagination. His conception of reality is inseparable from his inner vision, nourished and made visible to us by his rare capacity to see clearly and to render faithfully that which he sees.

The fascination peculiar to the work of Miró lies above all in his power to extend our sense of reality. His purpose is to lead us to those realms of anonymity that transcend painting, an aim which becomes increasingly evident in the clarity and vigour of his most recent burst of creativity. The persistence and integrity of his effort, and his willingness to renounce the exuberant charm of his earlier work, now give him the power he needs in his transcendental role as the seer who can take us with him into the highest regions of perception.

Epilogue

The dapper little man in a pinstripe suit and shiny black shoes, sitting beside me at the Marlborough Gallery in London one morning in 1966, was Joan Miró. 'The fork attacks the apple,' he said, 'as if it were a bayonet. The apple is Spain.'

60 He was explaining for my benefit the symbols in *Still-life with an old shoe*, painted in 1937 at the beginning of the Spanish Civil War. As he did so it became apparent that the revulsion he felt for Fascism, still in power at that time in Spain, was a reality as tangible as the objects in his painting. Something *real* was needed to fight the hideous reality of oppression and injustice. In 1970, in a rather untypical gesture for such a private man, he joined Antoni Tàpies and other Catalan artists and intellectuals in a march to Montserrat Abbey to protest against the death sentences passed on several members of the Basque group ETA at the notorious Burgos trial.

From then on Miró appeared to be quite happy to let us know he was going to take notice more openly of the real world. He acknowledged, for instance, the oil crisis of 1973, and the sudden awareness that natural resources are finite, by enhancing the dominant role of black in his paintings and graphic work; symbolically, he was economizing in the use of *137* colour. His *Sobreteixims* (1973), a series of works on rough jute mats, would seem to indicate a positive reaction to the ecological ideas taking shape all around him, although some might prefer to interpret them as a return to his peasant roots: both interpretations, in any case, are compatible.

During that period – the early 1970s – he began to feel an urge for his message to reach a greater number of people, and, as a result, his graphic output increased dramatically. The colours were as radiant as ever, but they were now controlled by

138 *Landscape* 1974

imposing, black surroundings, as in the lithographs *The Amorous Bird* (1973) or *Montroig III* (1973), or in paintings like *138 Landscape* (1974), where a massive, black, trapezoidal shape completely overwhelms a strip of green background. Miró's blacks have been compared to his silences – the lack of colour to the lack of sound, both serene and mysterious. The black, however, reaches further, its impact being visual: a presence, in the troubled world of his old age, rather than an absence.

Throughout the 1970s Miró worked with Artigas on ceramic murals for public places. He designed one for IBM in Barcelona in 1976, using a brush, a watering can and, sometimes, a bucket to apply the black; and, in 1980 he finished the maquette for the very large mural at the Palace of Congresses and Exhibitions in Madrid.

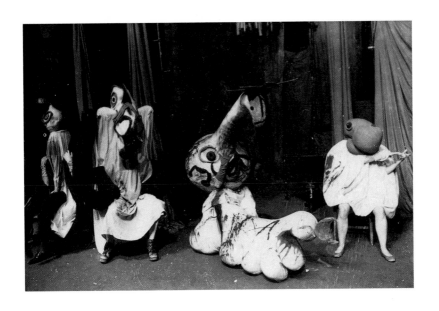

139–140 Scenes from *Mori el Merma*, with La Claca, London 1978

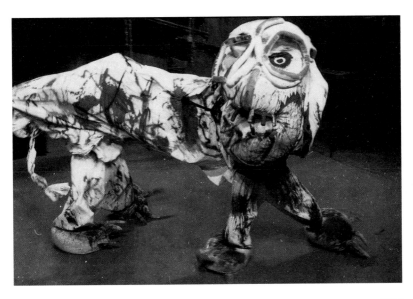

Like Goya, and most great artists before him, he was anxious to go on learning until the end. In 1976 he collaborated with 'La Claca', an enthusiastic group of young Catalan actors, designing and painting for them a whole cast of biomorphic creatures headed by a grotesque and inimitable version of Jarry's Père Ubu, who steps effortlessly into the shoes of the, then, recently dead Spanish dictator. The ensuing show, *Mori el Merma*, played to full houses in Majorca, Barcelona, the Pompidou Centre in Paris, and Riverside Studios in London.

At eighty-four, Miró used the technique of monotype for the first time; and two years later, in 1979, he produced his first stained glass windows ever for the Fondation Maeght at Saint-Paul de Vence, where his sculptures welcome the visitor on the sun-drenched terraces of a Provençal garden. He then created a suite of drawings so that music could be composed around them for the ballet *L'Uccello Luce*, first performed at the Teatro La Fenice in Venice in 1981.

A year later, he gave us *Personnage*, an outer-space, warrior-like figure in bronze, who casts a sinister eye on Earth. An omen?

The old master was getting very frail, sustained only by the sight of the stars in the Mediterranean sky. On 25 December 1983, he finally reached for the step-ladder, always close at hand, and climbed into the night of times, his beloved night.

EDUARDO DE BENITO

Text references

Bibliographical details not given here will be found in the Bibliography

CHAPTER ONE (pages 7–31)

1 Guillaume Apollinaire, *Les Peintres cubistes* (Geneva, Cailler, 1956), p. 36.
2 Ibid.
3 Dupin, p. 129 (132). All quotations from Dupin are my own translations from the French original; page references to the English edition are given in parentheses.
4 Ibid., p. 76 (76).
5 Ibid., p. 129 (132).

CHAPTER TWO (pages 32–64)

1 Sweeney, 'Joan Miró, Comment and Interview', p. 209.
2 Breton, *Le Surréalisme et la peinture*, p. 94.
3 *La Révolution surréaliste*, no. 3 (April 1925).
4 Miró, 'Je travaille comme un jardinier', p. 45.
5 Miró, 'Je rêve d'un grand atelier', p. 25.
6 Sweeney, *Joan Miró*, p. 13.
7 Jean and Mezei, p. 154.
8 Breton, *Le Surréalisme et la peinture*, p. 68.
9 Sweeney, 'Joan Miró, Comment and Interview', p. 209.
10 Hunter, p. xxxv.
11 Herbert Read, *The Art of Jean Arp* (London, Thames and Hudson; New York, Abrams, 1968), p. 114.
12 Hunter, p. xxx.
13 Jean Arp, *Jours effeuillés* (Gallimard, Paris 1968).
14 *La Révolution surréaliste*, no. 7 (June 1926).
15 *La Révolution surréaliste*, no. 8 (December 1926).
16 Paul Eluard, *A Toute Epreuve* (Geneva, Gérald Cramer, 1958).
17 Waldberg, *Surrealism*, p. 41.

CHAPTER THREE (pages 65–99)

1 Duthuit, p. 261.
2 Ibid.

3 Breton, *Les Constellations*, pp. 10–11.
4 Fitzsimmons (no page number).
5 Miró, 'Je travaille comme un jardinier', p. 45.

CHAPTER FOUR (pages 100–11)

1 Breton, *Les Constellations*, p. 8.
2 Hunter, p. xxix.
3 Breton, *Les Constellations*, p. 11.
4 Sweeney, 'Joan Miró, Comment and Interview', p. 211.
5 Hunter, pp. xxvi, xxix.
6 Ibid.

CHAPTER FIVE (pages 112–40)

1 Dupin, p. 376 (382).
2 Miró, 'Je rêve d'un grand atelier', p. 25.
3 Dupin, p. 466 (482).

CHAPTER SIX (pages 141–69)

1 Bernier, p. 46.
2 Dupin, p. 384 (432).
3 Dupin, p. 444 (476).

CHAPTER SEVEN (pages 170–201)

1 Miró, 'Je travaille comme un jardinier', pp. 39, 43 (translation adapted).
2 Dupin, p. 432 (464).
3 Miró, 'Je travaille comme un jardinier', p. 44.
4 Ibid., p. 43.
5 Ibid., p. 39.
6 Waldberg, 'Le Miromonde', p. 25.
7 Miró, 'Je travaille comme un jardinier', p. 47.
8 Ibid., p. 48.
9 Mircea Eliade, *Myths, Dreams and Mysteries* (London, Collins, 1968), p. 62.
10 Ibid., p. 125.

11 Antonin Artaud, *Œuvres complètes* (Paris, Gallimard, 1967), VII, 24.
12 Stéphane Mallarmé, *Œuvres complètes* (Paris, Gallimard, 1945), pp. 455, 477.
13 R. D. Laing, *The Politics of Experience* (Harmondsworth, Penguin Books, 1967), p. 36.

14 Miró, 'Je travaille comme un jardinier', p. 39.
15 Charles Baudelaire, *The Mirror of Art* (London, Phaidon, 1955), p. 144.
16 Max Jacob, *Correspondance* (Paris, Editions de Paris, 1953), I, 31.

Bibliography

Barr, Alfred H., Jr, ed. *Fantastic Art, Dada, Surrealism*. New York, Museum of Modern Art, 1936.

Bernier, Rosamond. 'Miró céramiste. *L'Œil*, no. 17 (May 1956).

Bonnefoy, Yves. *Miró*. Milan, Silvana Editoriale d'Arte, 1964.

Breton, André. *Le Surréalisme et la peinture*. New York, Brentano's, 1945. This is a revised version of a text first published in *La Révolution surréaliste*, nos. 4, 6, 7, 9, 10 (1927).

———. *Les Constellations*. New York, Pierre Matisse Gallery, 1959.

Cirici Pellicer, Alejandro. *Miró y la imaginación*. Barcelona, Omega, 1949.

Dupin, Jacques. *Joan Miró: la vie et l'oeuvre*. Paris, Flammarion, 1961. English translation: *Joan Miró: Life and Work*. New York, Abrams; London, Thames and Hudson, 1962. Clmprehensive bibliography by Bernard Karpel.

———. *Miró*. Paris, Unesco; London, Collins, 1962.

Duthuit, Georges. 'Où allez-vous, Miró?'. *Cahiers d'Art*, vol. XI, nos. 8–10 (1936).

Erben, Walter. *Miró*. London, Lund Humphries, 1959.

Fitzsimmons, James. *Miró – 'Peintures sauvages' 1934–53*. New York, Pierre Matisse Gallery, 1958.

Gomis, Joaquim, and Joan Prats Vallés. *Atmósfera Miró* (with English translation). Barcelona, Ediciones Polígrafa, 1959. Preface by James Johnson Sweeney.

———. *Creación Miró 1961* (with English translation). Barcelona, Ediciones Polígrafa, 1962. Preface by Yvon Taillandier.

———. *Creación en el espacio de Joan Miró* (with English translation). Barcelona, Ediciones Polígrafa, 1966. Preface by Roland Penrose.

Greenberg, Clement. *Joan Miró*. New York, Quadrangle Press, 1949.

Hunter, Sam. *Joan Miró: His Graphic Work*. New York, Abrams, 1958.

Jean, Marcel, and Arpad Mezei. *Histoire de la peinture surréaliste*. Paris, Editions du Seuil, 1959. English translation: *History of Surrealist Painting*, New York, Grove Press, 1960; London, Weidenfeld and Nicolson, 1962.

Lassaigne, Jacques. *Miró*. Lausanne, Skira, 1963.

Miró, Joan. 'Je rêve d'un grand atelier'. *XX^e Siècle*, vol. I, no. 2 (1938), p. 25.

———. 'Je travaille comme un jardinier. Propos recueillis par Yvon Taillandier' (with English translation by Joyce Reeves). *XX^e Siècle*, vol. X, no 1 (1959), p. 45.

Penrose, Roland. *Miró*. 'The Masters' series. Bristol, Purnell, 1965.

Perucho, Juan. *Joan Miró y Cataluña* (with English translation). Barcelona, Ediciones Polígrafa, 1968.

Prévert, Jacques, and Georges Ribemont-Dessaignes. *Joan Miró*. Paris, Maeght, 1956.

Soby, James Thrall. *Joan Miró*. New York, Museum of Modern Art, 1959.

Sweeney, James Johnson. *Joan Miró.* New York, Museum of Modern Art, 1941.
———. 'Joan Miró, Comment and Interview'. *Partisan Review*, vol. XV, no. 2 (1948).
Waldberg, Patrick. *Surrealism.* London, Thames and Hudson; New York,

McGraw-Hill, 1965.
———. 'Le Miromonde'. *Derrière le miroir*, nos. 164–5 (April–May 1967), p. 25.
Zervos, Christian, ed. 'L'OEuvre de Joan Miró de 1917 à 1933'. *Cahiers d'Art*, vol. IX, nos. 1–4 (1934). Special number.

List of illustrations

Measurements are given in inches and centimetres; height precedes width.

18 *The Farmer's Wife* 1922–3. Oil on canvas $31\frac{7}{8}$ × $25\frac{5}{8}$ (81 × 65). Mrs Marcel Duchamp, New York.

19 *The Ploughed Field* 1923–4. Oil on canvas 26 × 37 (66 × 94). Mr and Mrs Henry Clifford, Radnor, Pa.

20 *Harlequin's Carnival* 1924–5. Oil on canvas 26 × $36\frac{5}{8}$ (66 × 93). Albright-Knox Art Gallery, Buffalo, N.Y.

21 *Dialogue of the insects* 1924–5. Oil on canvas $25\frac{5}{8}$ × $36\frac{1}{4}$ (65 × 92). Heinz Berggruen, Paris.

22 *Catalan landscape (The Hunter)* 1923–4. Oil on canvas $25\frac{5}{8}$ × $39\frac{3}{8}$ (65 × 100). The Museum of Modern Art, New York. Purchase.

23 *Portrait of Madame K* 1924. Oil and charcoal on canvas $45\frac{1}{4}$ × 35 (115 × 89). Private collection. Photo The Arts Council of Great Britain.

24 *The Family* 1924. Black and red chalk on emery paper. $29\frac{1}{2}$ × 41 (75 × 104). The Museum of Modern Art, New York. Gift of Mr and Mrs Jan Mitchell.

25 *Maternity* 1924. Oil on canvas $35\frac{7}{8}$ × $29\frac{1}{8}$ (91 × 74). Private collection, London.

26 *Head of Catalan peasant* 1925. Oil on canvas $35\frac{7}{8}$ × $28\frac{3}{4}$ (91 × 73). Private collection, London. Photo John Webb (Brompton Studio).

27 *Ceci est la couleur de mes rêves* 1925. Oil on canvas approx. 32 × $39\frac{3}{8}$ (81 × 100). Pierre Matisse Gallery, New York. Photo Eric Pollitzer.

28 *Head of a pipe-smoker* 1925. Oil on canvas $25\frac{1}{4}$ × $19\frac{1}{4}$ (64 × 49). Private collection, London. Photo John Webb (Brompton Studio).

29 *Painting* 1925. Oil on canvas $44\frac{1}{2}$ × $56\frac{3}{4}$ (113 × 144). Peggy Guggenheim Foundation, Venice.

30 *Lovers* 1925. Oil on canvas $28\frac{3}{4}$ × $34\frac{3}{4}$ (73 × 91). Pierre Matisse Gallery, New York.

31 *The Birth of the World* 1925. Oil on canvas $96\frac{1}{2}$ × $76\frac{3}{4}$ (245 × 195). Private collection.

32 *Le corps de ma brune . . .* 1925. Oil on canvas $51\frac{1}{8}$ × $37\frac{3}{4}$ (130 × 96). Mr and Mrs Maxime Hermanos, New York.

33 *Un oiseau poursuit une abeille et la baisse* 1927. Oil and collage on canvas $31\frac{7}{8}$ × $39\frac{3}{8}$ (81 × 100). Private collection, New York. Photo Nathan Rabin.

34 *Amour* 1926. Oil on canvas $44\frac{7}{8}$ × $57\frac{1}{2}$ (114 × 146). Wallraf-Richartz Museum, Cologne.

35 *Le signe de la mort* 1927. Oil on canvas $28\frac{3}{4}$ × $36\frac{1}{4}$ (73 × 92). Private collection. Photo The Arts Council of Great Britain.

36 *Dog barking at the moon* 1926. Oil on canvas $28\frac{3}{4}$ × $36\frac{1}{4}$ (73 × 92). Philadelphia Museum of Art. Gallatin collection.

37 *Person throwing a stone at a bird* 1926. Oil on canvas $28\frac{3}{4}$ × $36\frac{1}{4}$ (83 × 92). The Museum of Modern Art, New York. Purchase.

38 HENDRICK MAERTENSZ. SORGH. *The Lute Player* 1661. Oil on panel $20\frac{1}{2}$ × $15\frac{1}{4}$ (52 × 39). Rijksmuseum, Amsterdam.

39 *Dutch Interior* 1928. Oil on canvas $36\frac{1}{4}$ × $28\frac{3}{4}$ (92 × 73). The Museum of Modern Art, New York. Mrs Simon Guggenheim Fund.

40 *The Potato* 1928. Oil on canvas $31\frac{7}{8}$ × $39\frac{3}{8}$ (81 × 100). Private collection, New York. On loan to the Metropolitan Museum of Art, New York.

41 *Portrait of Mrs Mills in 1750* 1929. Oil on canvas $45\frac{5}{8}$ × 35 (116 × 89). James Thrall Soby, New Canaan, Conn. Photo The Museum of Modern Art, New York.

42 *Spanish dancer* 1928. Collage-object. Galerie Maeght, Paris.

43 *Collage* Summer 1929. Collage $39\frac{3}{4} \times 26$ (101 × 66). Sra Pilar Juncosa de Miró, Palma de Mallorca. Photo F. Catalá Roca.

44 *Drawing-collage* 8 September 1933. Conté crayon and collage on pastel paper $42\frac{1}{2} \times 28\frac{3}{8}$ (108 × 72). Pierre Matisse Gallery, New York.

45 *Torso of a nude woman* 1931. Oil on Ingres paper $24\frac{3}{4} \times 18\frac{1}{8}$ (63 × 46). Philadelphia Museum of Art. Arensberg collection.

46 *Seated woman* 1932. Oil on wood $18\frac{1}{8} \times 15$ (46 × 38). Private collection, New York. Photo courtesy Pierre Matisse Gallery.

47 *Painting* 1933. Oil on canvas $68\frac{1}{8} \times 76\frac{3}{4}$ (173 × 195). The Museum of Modern Art, New York. Gift of the Advisory Committee.

48 *Painting* 1933. Oil on canvas $52\frac{3}{8} \times 65\frac{3}{8}$ (133 × 166). Narodní Galerie, Prague.

49 Preliminary collage 1933. For *Painting* 1933 (*Ill. 47*). Sra Pilar Juncosa de Miró, Palma de Mallorca.

50 Preliminary collage 1933. For *Painting* 1933 (*Ill. 48*). Sra Pilar Juncosa de Miró, Palma de Mallorca.

51 *Woman* 1934. Pastel on pastel paper $41\frac{3}{4} \times 28$ (106 × 71). Private collection, Paris. Photo courtesy Galerie Maeght.

52 *Persons in the presence of nature* 1 February 1935. Oil on cardboard $29\frac{1}{2} \times 41\frac{3}{4}$ (75 × 106). Philadelphia Museum of Art. Arensberg collection.

53 *The Farmers' Meal* 3 March 1935. Oil on cardboard $29\frac{1}{2} \times 41\frac{3}{4}$ (75 × 106). Mr and Mrs Thomas Adler, Cincinnati, Ohio. Photo The Arts Council of Great Britain.

54 *The Two Philosophers* 4–12 February 1936. Oil on copper $13\frac{3}{4} \times 19\frac{5}{8}$ (35 × 50). Pierre Matisse Gallery, New York.

55 *Two personages in love with a woman* 29 April–9 May 1936. Oil on copper $10\frac{1}{4} \times 13\frac{3}{4}$ (26 × 35). Private collection. Photo courtesy Pierre Matisse Gallery.

56 *Man and woman in front of a pile of excrement* 5–22 October 1935. Oil on copper $12\frac{5}{8} \times 9\frac{7}{8}$ (32 × 25). Sra Pilar Juncosa de Miró, Palma de Mallorca. Photo F. Catalá Roca.

57 *Two personages* 1935. Oil and collage on cardboard. $41 \times 29\frac{1}{8}$ (106 × 75). Mr and Mrs David Lloyd Kreeger, Washington DC.

58 *Rope and people I* 27 March 1935. Oil and rope on cardboard $41\frac{3}{4} \times 29\frac{1}{2}$ (106 × 75). The Museum of Modern Art, New York.

59 *Painting on masonite* Summer 1936. Oil, casein, tar and sand on masonite $30\frac{3}{4} \times 39\frac{3}{8}$ (78 × 100). Aimé Maeght, Paris. Photo courtesy Galerie Maeght.

60 *Still-life with an old shoe* 24 January–29 May 1937. Oil on canvas $31\frac{7}{8} \times 45\frac{5}{8}$ (81 × 116). James Thrall Soby, New Canaan, Conn.

61 *The Reaper* 1937. Oil on celotex 18 ft $0\frac{1}{2}$ in × 11 ft $11\frac{3}{4}$ in (550 × 365). Formerly a in the pavilion of the Spanish Republic at the Paris World's Fair. Now lost. Photo courtesy Galerie Maeght.

62 *Aidez l'Espagne* 1937. Silkscreen print $9\frac{3}{4} \times 7\frac{1}{2}$ (25 × 19). Private collection, London. Photo R.B. Fleming.

63 *Portrait I* May 1938. Oil on canvas $64\frac{1}{4} \times 51\frac{1}{4}$ (163·5 × 129·5). Baltimore Museum of Art. Saidie A. May collection.

64 *Woman's head* 5 October 1938. Oil on canvas $21\frac{5}{8} \times 18\frac{1}{8}$ (55 × 46). Mr and Mrs Donald Winston, Los Angeles.

65 *Une étoile caresse le sein d'une négresse* 1938. Oil on canvas 51⅛ × 77⅞ (130 × 196). Pierre Matisse Gallery, New York.

66 *Seated woman I* 4 December 1938. Oil on canvas 63¾ × 51⅛ (162 × 130). Peggy Guggenheim Foundation, Venice.

67 *Woman in front of the sun* 1938. Oil on canvas 21⅝ × 18⅛ (55 × 46). Mrs Barbara Reis Poe, New York. Photo courtesy Pierre Matisse Gallery.

68 *Self-portrait I* 1937–8. Pencil, crayon and oil on canvas 57½ × 38⅛ (146 × 97). James Thrall Soby, New Canaan, Conn. Photo The Museum of Modern Art, New York.

69 *Self-portrait II* 1938. Oil on canvas 51⅛ × 76 (130 × 195). Private collection. Photo courtesy Pierre Matisse Gallery.

70 *Self-portrait* 1937–60. Oil on canvas 57½ × 38⅛ (146 × 97). Sra Pilar Juncosa de Miró, Palma de Mallorca. Photo courtesy Galerie Maeght.

71 *Flight of a bird over a plain IV* July 1939. Oil on canvas 31⅞ × 39⅜ (81 × 100). Eric R. Estorick.

72 *Woman beside a lake whose surface has been made iridescent by a passing swan* 14 May 1941. Gouache and oil on paper 18⅛ × 15 (46 × 38). Private collection, Norfolk, Conn. Photo courtesy Pierre Matisse Gallery.

73 *Pink twilight caresses the genitals of women and birds* 14 August 1941. Gouache and oil wash on paper 18⅛ × 15 (46 × 38). Private collection. Photo courtesy Pierre Matisse Gallery.

74 *Women encircled by the flight of a bird* 27 April 1941. Gouache and oil wash on paper 18⅛ × 15 (46 × 38). Private collection, Paris. Photo Arts Graphiques de la Cité.

75 *The nightingale's song at midnight and morning rain* 4 September 1940. Gouache

and oil wash on paper 15 × 18⅛ (38 × 46). H. Cameron Morris, Jr, Osterville, Mass. Photo courtesy Pierre Matisse Gallery.

76 *People in the night guided by the phosphorescent tracks of snails* 12 February 1940. Gouache and oil wash on paper 15 × 18⅛ (38 × 46). Leonard B. Stern, New York. Photo courtesy Pierre Matisse Gallery.

77 *Barcelona Suite IV* 1944. Lithograph 25¾ × 18¾ (65 × 48). Galerie Maeght, Paris.

78 *The Ladder of Escape* 31 January 1940. Gouache and oil wash on paper 15 × 18⅛ (38 × 46). Mrs George Acheson, New York.

79 *Dancer listening to the organ in a Gothic cathedral* 26 May 1945. Oil on canvas 76¾ × 51⅛ (195 × 130). Private collection.

80 *Women and birds in the moonlight* 1 June 1949. Oil on canvas 31⅞ × 25⅝ (81 × 65). By courtesy of the Trustees of the Tate Gallery, London.

81 *People in the night* 11 March 1950. Oil on canvas 35 × 45¼ (89 × 115). Mrs Genia Zadok, New York.

82 *The blaze of the sun wounds the lingering star (Sunburst wounds the tardy star)* 1951. Oil and casein on canvas 23⅝ × 31⅞ (60 × 81). Gustav Zumsteg, Zurich. Photo Walter Dräyer.

83 *Painting* 1950. Oil, cords and casein on canvas 39 × 29⅞ (99 × 76). Stedelijk van Abbemuseum, Eindhoven.

84 *Woman in front of the sun* 1949. Oil on canvas 45⅝ × 35 (116 × 89). Galerie Maeght, Paris.

85 *Hope comes back to us as the constellations flee* 2 October 1954. Oil on canvas 44⅞ × 57½ (114 × 146). Galerie Maeght, Paris.

86 *The heavens half open give us back our hope (The half open sky gives us hope)* 19 July 1954. Oil on canvas 51⅛ × 76¾ (130 ×

195). Private collection. Photo courtesy Pierre Matisse Gallery.

87 *Painting* 1953. Oil on canvas 6 ft 4¾ in × 12 ft 4¾ in (195 × 378). The Solomon R. Guggenheim Museum, New York.

88 *Swallow dazzled by the flash of the red pupil* 1925–60. Oil on canvas 92½ × 69⅝ (235 × 177). Galerie Maeght, Paris.

89 *Woman struggling to reach the unattainable* 12 January 1954. Oil on canvas 27⅛ × 19⅝ (69 × 50). Galerie Maeght, Paris.

90 *Woman and bird II/X* 27 April 1960. Oil on burlap, 36¼ × 23⅝ (92 × 60). Galerie Maeght, Paris.

91 *Painting I/V* 1960. Oil on canvas 36¼ × 28¾ (92 × 73). Galerie Maeght, Paris.

92 *Painting II/V* 1960. Oil on canvas 31⅞ × 25⅝ (81 × 65). Galerie Maeght, Paris.

93 *Painting on torn cardboard* 1960. 10⅝ × 13⅜ (27 × 34). Galerie Maeght, Paris.

94 *The Red Disc* 1960. Oil on canvas 51⅛ × 65 (130 × 165). Victor K. Kiam, New York. Photo F. Catalá Roca.

95 *Blue III* 4 March 1961. Oil on canvas 106¼ × 139¾ (270 × 355). Pierre Matisse Gallery, New York. Photo F. Catalá Roca.

96 *Words of the poet* 5 June 1968. Oil on canvas 51⅛ × 76¾ (130 × 195). Sra Pilar Juncosa de Miró, Palma de Mallorca. Photo F. Catalá Roca.

97 *Letters and numbers attracted by a spark III* 1968. Oil on canvas 57⅞ × 46⅞ (145·5 × 114). Sra Pilar Juncosa de Miró, Palma de Mallorca. Photo F. Catalá Roca.

98 *Woman and birds at night* 4 April 1968. Oil on canvas 18⅛ × 105⅝ (46 × 27). Sra Pilar Juncosa de Miró, Palma de Mallorca. Photo F. Catalá Roca.

99 *Dance of people and birds against a blue sky* 25 May 1968. Oil on canvas 68½ × 75⅝ (174 × 192). Sra Pilar Juncosa de Miró, Palma de Mallorca. Photo F. Catalá Roca.

100 *Poem III* 17 May 1968. Oil on canvas 80¾ × 68½ (205 × 174). Sra Pilar Juncosa de Miró, Palma de Mallorca. Photo F. Catalá Roca.

101 *The Gold of the Azure* 4 December 1967. Oil on canvas 80¾ × 68⅞ (205 × 175). Sra Pilar Juncosa de Miró, Palma de Mallorca. Photo F. Catalá Roca.

102 *Flight of a bird enticing the woman with three hairs during a moonlight night* 14 April 1968. Oil on canvas 36¼ × 28⅜ (92 × 72). Sra Pilar Juncosa de Miró, Palma de Mallorca. Photo F. Catalá Roca.

103 *Woman in front of the eclipse, her hair ruffled by the wind* 13 September 1967. Oil on canvas 94½ × 76¾ (240 × 195). Sra Pilar Juncosa de Miró, Palma de Mallorca. Photo F. Catalá Roca.

104 *Woman surrounded by a flight of birds in the night* 28 May 1968 Oil on canvas 132⅝ × 132⅝ (337 × 337). Sra Pilar Juncosa de Miró, Palma de Mallorca. Photo F. Catalá Roca.

105 *Man and woman* March 1931. Painting-object 13⅜ × 7⅛ (34 × 18). Private collection, Paris. Photo Arts Graphiques de la Cité.

106 *Poetic object* 1936. Stuffed parrot on wood perch, stuffed silk stocking with velvet garter and paper shoe, bowler hat, cork ball, celluloid fish and engraved map 31⅞ × 11⅞ × 10¼ (81 × 30 × 26). The Museum of Modern Art, New York. Gift of Mr and Mrs Pierre Matisse.

107 *Object of sunset* 1938. Painting-object 26¾ × 17⅜ × 10¼ (68 × 44 × 26). Private collection, Paris. Photo Arts Graphiques de la Cité.

108 *Ceramic figure* 1956. Ceramic (h) 8¼ (21). Galerie Maeght, Paris. Photo F. Catalá Roca.

109 *Person with a large head.* Ceramic (h) 39½ (100). Mr and Mrs Pierre Matisse, New York. Photo Pierre Matisse Gallery.

110 *Monument to maternity (Woman)* 1962. Ceramic and wood 63¾ × 24¾ (162 × 62·8). Aimé Maeght, Paris. Photo courtesy Galerie Maeght.

111 *Sculpture* 1968. Bronze 37⅞ × 24¾ × 7⅞ (95 × 63 × 20). Cast by José Parellada, Barcelona.

112 *Sculpture* 1968. Bronze 68⅞ × 27⅝ × 9⅞ (175 × 70 × 25). Cast by José Parellada, Barcelona.

113 *Sculpture* 1968. Bronze 22 × 19⅜ × 2¼ (56 × 49·5 × 5·5). Cast by José Parellada, Barcelona.

114 *Woman (green)* 1968. Ceramic 29½ × 23⅝ × 17¾ (75 × 60 × 45).

115 *Harvard mural painting* 1950–1. Oil on canvas 6 ft 2¾ in × 19 ft 5¼ in (190 × 594). The Museum of Modern Art, New York. Mrs Simon Guggenheim Fund.

116 *Wall of the Moon* 1957. Ceramic tiles 7 ft 6½ in × 49 ft 6½ in (230 × 1510). Unesco building, Paris. Photo courtesy Unesco.

117 *Wall of the Sun* 1957. Ceramic tiles 7 ft 6½ in × 24 ft 7¼ in (230 × 750). Unesco building, Paris. Photo courtesy Unesco.

118 Study for a monument for Barcelona 1968. Bronze and cement 12 ft 5⅝ in × 3 ft 3⅜ in × 3 ft 3⅜ in (380 × 100 × 100). Mr and Mrs Pierre Matisse, New York. Photo Ediciones Polígrafa SA.

119 *Great arch* 1963. Cement with incrustations of stone 19 ft × 19 ft (580 × 580). Fondation Maeght, Saint-Paul de Vence. Photo courtesy Galerie Maeght.

120 *The Fork* 1963. Bronze and iron 16 ft 7⅝ in × 14 ft 11⅛ in (507 × 455). Fondation Maeght, Saint-Paul de Vence. Photo courtesy Galerie Maeght.

121 Lithograph for *Album 13* 1948. Lithograph 12 × 15¾ (30·5 × 40).

122 *Small engraving* 1953. Engraving in 2 states 2¾ × 3⅜ (7 × 8).

123 Illustration for Tristan Tzara's *Parler Seul* 1948–50. Lithograph 13 × 9⅞ (33 × 23·5).

124 *The Great Magician* 1968. Original colour etching 33 × 26 (89·5 × 66·4). Galerie Maeght, Paris.

125 *In the hail* 5 November 1969. *Gravures monumentales* series 16⅞ × 26¾ (43·5 × 68.5). Galerie Maeght, Paris.

126 *The Calabash* 1 August 1969. *Gravures monumentales* series 36¼ × 22⅞ (92 × 58). Galerie Maeght, Paris.

127 JEAN-BAPTISTE-CAMILLE COROT. *Landscape at Château-Thierry* 1855–65. Oil on canvas 15 × 21¾ (38 × 55·5). Oskar Reinhart, Winterthur.

128 *Homage to Corot* 5 December 1967. Oil on canvas 68⅞ × 80¾ (175 × 205). Sra Pilar Juncosa de Miró, Palma de Mallorca. Photo F. Catalá Roca.

129 Maquette for Barcelona airport mural 1969. To be ceramic tiles 32 ft 9 in × 164 ft (1000 × 5000).

130 *The skylark's wing encircled by the blue of gold rejoins the heart of the poppy that sleeps on the meadow adorned with diamonds* 13 March 1967. Oil on canvas 76¾ × 51⅛ (195 × 130). Sra Pilar Juncosa de Miró, Palma de Mallorca. Photo F. Catalá Roca.

131 *Silence* 17 May 1968. Oil on canvas 68½ × 96⅛ (174 × 244). Sra Pilar Juncosa de

Miró, Palma de Mallorca. Photo F. Catalá Roca.

Maeght, Paris. Photo Ediciones Polígrafa SA.

Index